W9-BIE-476

Postcard History Series

Perkasie

On the front cover: **SOUTH PERKASIE MILL, C. 1900.** Located along Pleasant Spring Stream, a tributary of the Perkiomen Creek, this flour and feed mill operated from the 1820s until 1978. Gristmills and their water source attracted farmers and workers. Like many early settlements, the mill often was one of the first businesses to be established. Before being annexed to Perkasie in 1898, South Perkasie was also known as Bridgetown and Benjamin. While this *c.* 1905 image shows James M. Savage as its operator, the Groff, Rosenberger, and Strassburger families also owned the mill during its early years. The Benfield family operated the mill for many years before it was converted into condominiums. Many of its early features and sign paintings survive. (Hockman collection.)

On the back cover: **MENLO PARK TOBOGGAN, C. 1910.** Menlo Park was Perkasie's amusement park from 1891 to the early 1960s. During its earliest years, Menlo Park was famous for its toboggan ride, claimed to be the longest in the world when it first ran in 1894. This very rare photograph postcard shows where riders got into the toboggan car. Gravity provided power for the 2,000-foot-long ride down the hillside to Lake Lenape. Today only a cement support wall and footings are evidence of this building's location near the Perkasie Carousel. See chapter 2 for more images and information about this unique ride and Perkasie's history as an amusement park center. (Hockman collection.)

POSTCARD HISTORY SERIES

Perkasie

Ivan J. Jurin

ARCADIA
PUBLISHING

Published by Arcadia Publishing
Charleston SC, Chicago IL, Portsmouth NH, San Francisco CA

Printed in the United States of America

Library of Congress Catalog Card Number: 2007937027

For all general information contact Arcadia Publishing at:
Telephone 843-853-2070
Fax 843-853-0044
E-mail sales@arcadiapublishing.com
For customer service and orders:
Toll-Free 1-888-313-2665

Visit us on the Internet at www.arcadiapublishing.com

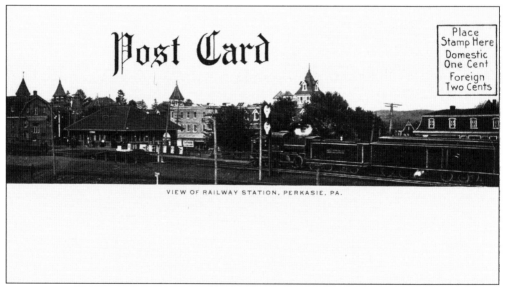

VIEW OF RAILWAY STATION, PERKASIE, PA.

PERKASIE RAILWAY STATION, 1903. With tall steeples and a line of hotels near the train station, Perkasie must have been impressive to passengers of the North Pennsylvania Railroad. Printer Charles Berkemeyer and the talented photographer Daniel Ziegler collaborated to create exceptional postcard series of Perkasie and other towns in upper Bucks and Montgomery Counties during the first decade of the 20th century. Ziegler had a talent of representing motion when cameras had slower shutter speeds. This image was on the back of all Berkemeyer postcards of Perkasie and neighboring communities with economic ties to Perkasie. See chapter 6 for more images and information about these nearby communities.

Contents

ACKNOWLEDGMENTS

Books are always a collaborative effort. While I must take responsibility for the book's content, I could not have completed this visual history of Perkasie without the significant help from the following people. The most important resource persons were Perkasie natives James I. Moyer and James Pritchard, both very active citizens who cared about preserving Perkasie's history.

James Pritchard spent many hours with me at the Perkasie Museum finding images and clarifying my uncertainties about Perkasie and its past. The Perkasie Historical Society and its president, Charles Baum, supported my research and publication of this book. Rare postcards and photographs from its museum collection greatly enhanced the telling of Perkasie's history. Donald K. Lederach's research on early Perkasie was used. The guidance and encouragement given by my Arcadia Publishing editor Erin Vosgien was greatly appreciated.

Many of the postcards found in *Perkasie* are from the extensive collection of Dr. Walter Hockman and his wife Eileen (Hockman collection). We share a love of local history told through photograph postcards. The Bucks County Historical Society contributed with a rare postcard of the Perkasie Tunnel and with its extensive local history archives. Images without acknowledgement are from the author's collection.

I relied on James I. Moyer's *History of Perkasie: Through the Eyes of the Central News, 1881 to 1945* to acquire accurate information and the story line about early Perkasie. The *Central News* was Perkasie's original newspaper. *Perkasie* is intended to compliment the narrative histories of Moyer's book and Perkasie's anniversary celebration booklets of 1929, 1954, and 1979 (see bibliography, page 127). Perkasie is fortunate to have a rich visual history available. In creating this book, I reviewed more than 500 historical postcards and vintage photographs of Perkasie spanning from the 1870s to the 1920s. I found it challenging to determine which images would be included in this book. I hope *Perkasie* generates interest in local history through the study of visual records. Perkasie is an excellent example of the economic, social, and cultural changes occurring in America in the late 19th and early 20th centuries.

INTRODUCTION

Think local history is boring? Not in Perkasie! This book shows that Perkasie was a boomtown of the late 1800s and was a significant transportation, manufacturing, and entertainment center until the 1940s. Perkasie's early history includes things such as the excavation of a railroad tunnel, the tunnel workers riot, a cholera outbreak, how local entrepreneurs "make" Perkasie, the thousands of summer visitors, and the 52 million cigars produced in 1907. Perkasie was an important summer retreat and resort for the Philadelphia region. Perkasie's Menlo Park was a major amusement park established by trolley and railroad networks. People came to experience the world's longest toboggan ride. Three near-catastrophic fires, railroad accidents, and fraternal conventions are ingredients of Perkasie's early history. First, we must recognize the earliest people who lived in the area that became Perkasie.

Perkasie's name is believed to mean "where hickory nuts were cracked" in the language of the original Native American inhabitants, the Lenni Lenape or Delaware. Their stone tools and potsherds have been found along the Perkiomen Creek and its small tributaries where the Lenape had their villages and did most of their hunting. As Europeans migrated out from Philadelphia during the early 1700s, Native Americans started to move away. When the Walking Purchase of 1737 cheated the Lenape out of most of their land, they emigrated from southeast Pennsylvania. Regrettably William Penn's heirs did not respect the Native Americans and their rights like he had done. William Penn met with the Lenape chief Tamanend at "Pocasie" in 1683. This is when Penn established his large country manor of Perkasie, which included most of today's Hilltown and Rockhill Townships.

The Stout family is recognized as the first Europeans to permanently settle in the area that became Perkasie. John Jacob Stout was a German-speaking native of Switzerland who immigrated to Pennsylvania in 1737. He traveled to Bucks County and was able to acquire 800 acres in the Perkasie Manor. Jacob was a skilled potter. The earliest known pieces of Pennsylvania German redware were created by Stout and his stepson John Lacey (Leisse). Both have pottery masterpieces in the Philadelphia Art Museum. Jacob Stout, his wife, sons, and their families are buried in the Stout Burial Ground, located at Eighth and Chestnut Streets in Perkasie.

Few improvements were done with the future site of Perkasie until the early 1850s, when the North Pennsylvania Railroad Company surveyed a 60-mile route that would connect Philadelphia with Bethlehem. Railroads had avoided this part of Bucks County because of the very steep Landis' Ridge, today known as "the ridge." In 1853, the railroad company started its excavation through Landis' Ridge. The digging went slowly. Irish immigrant laborers did most of the tunnel excavation. Company engineers and the Irish workers encountered serious problems, including cutting through layers of solid rock, rocks falling from the tunnel's ceiling, and enduring spartan living conditions. It took three years to complete the tunnel. The first contractor was fired after only one year.

Shortly after the second contractor started, cholera broke out in the large labor camp and many workers died. They were buried in unmarked graves in the Kellers Church Cemetery and on the farm located atop the tunnel. A year later, the Pennsylvania National Guard was called out to quell a riot by the Irish laborers. They were irate because their wages were reduced by the contractor. Finally in December 1856, the tunnel was completed. It was 2,200 feet in length

with a slight curve that connected a single track line from Bethlehem with the south-bound Philadelphia line. The tunnel's opening set the stage for a new railroad station and town to be established along the North Pennsylvania Railroad line. That town would become Perkasie.

South Perkasie has its own early history dating before the Perkasie Tunnel was built. South Perkasie was known as Bridgetown because one had to use a bridge to travel to this village. It was a commercial center with crossroads leading to Hilltown, Sellersville, and Quakertown, now the intersection of Main and Walnut Streets. In 1856, Bridgetown had two churches, two gristmills, a store, hotel, schoolhouse, and nearly 30 homes. The village got a post office in 1887 and was renamed Benjamin, after Benjamin Althouse, a Civil War veteran. Benjamin was not part of Perkasie when it was incorporated in 1879. In 1894, Benjamin's leading citizens petitioned Bucks County to be incorporated as its own borough, a self-governing town, but that request was denied. Perkasie was able to annex the land between itself and Benjamin in 1896. Two years later, Benjamin (South Perkasie) was annexed to Perkasie, more than doubling its size.

Railroads reigned as the vital big business after the Civil War. The railroad tunnel made the town of Perkasie possible. If anyone could be called the "father of Perkasie" it would be Samuel Hager from the small village of Hagersville, just three miles east of Perkasie. A dirt road went from Hagersville in Bedminster Township to Sellersville, now Fifth Street in Perkasie. The new train tunnel was just a quarter mile from this road. Samuel Hager saw a business opportunity. He built a woolen mill and railroad switch hoping that trains would stop. They did not, and Hager sold his mill to Joseph A. Hendricks, who converted it into a general store. In 1871, Perkasie's first train station was opened on the store's second floor. That building is the current Treasure Trove Building on the north side of Seventh and Market Streets. In 1873, only three houses and several businesses stood where Perkasie would exist six years later. Perkasie's incorporation in 1879 occurred shortly after the North Pennsylvania Railroad Company decided to have its company coal and water depot at Mount Alto, near the current post office.

Farming communities of Rockhill, Bedminster, and Hilltown Townships needed a quicker way of getting their products to urban markets. Perkasie promptly became a shipping center for the surrounding villages and farms with numerous freight trains stopping each day. The local farmers met the daily 6:00 a.m. milk train with their milk cans for quick delivery to Philadelphia. Perkasie's freight yards worked nearly around the clock. Frequent passenger trains permitted local residents to commute to city jobs. Express trains traveling between major cities sped through Perkasie.

Changes in mass transportation enabled towns like Perkasie in rural Bucks County to attract commuting workers to its cigar and clothing factories. Industries used railroad freight trains to bring raw materials to their Perkasie factories and to transport their finished products to market. Trolley service came to Perkasie in 1900, linking it to towns between Allentown and Philadelphia, and beyond. Trolleys brought many workers to Perkasie. A study of the 1894 business directory reveals that cigar manufacturing was Perkasie's dominant occupation with nearly 30 percent of its men having a job related to cigar-making. Within another 10 years, cigar making employed 2,000 people, more than Perkasie's population. Other industries and businesses of early Perkasie were hotels, clothing, ice cream, brickyards, tomato processing, and baseball and softball manufacturing.

With the advent of increased leisure time in the late 1800s, amusement parks and summer retreats flourished. Perkasie Park was a prime example of a summer retreat established by church congregations. In 1892, Menlo Park was started and had a carousel housed under a tent. This amusement park expanded in size and in different attractions. There were thousands of visitors each year who came mainly by trolley. Menlo became famous as a trolley park until 1950. Today the famous Menlo Carousel still gives rides by the Perkasie Historical Society.

The postcard history of *Perkasie* describes the rapid growth from the 1880s to 1920s told through photographic images and detailed captions. Perkasie experienced a boom time when the United States was rapidly changing in how and where Americans worked, lived, and relaxed. This theme runs throughout the photographs and postcards of Perkasie and its nearby communities.

One

TRANSPORTATION
BOOMTOWN

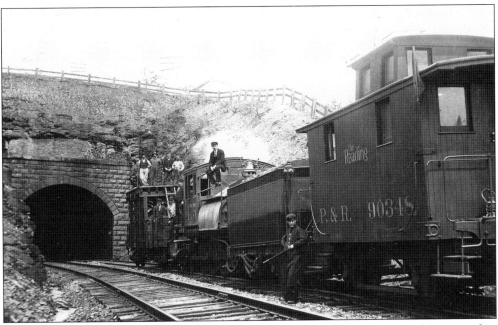

MAINTENANCE TRAIN AT TUNNEL, C. 1905. This tunnel made Perkasie possible. It was first called the Sellersville Tunnel when it was completed in 1858 because Perkasie did not exist. The tunnel was a major engineering and commercial accomplishment that permitted freight and passengers to be transported between Philadelphia, Allentown, and Bethlehem. Problems with its construction caused workers' deaths, and it took more than three years to complete. The falling rocks from the tunnel ceiling plagued traffic for several decades. This is a maintenance crew with a makeshift platform to work on the tunnel's ceiling. (Bucks County Historical Society.)

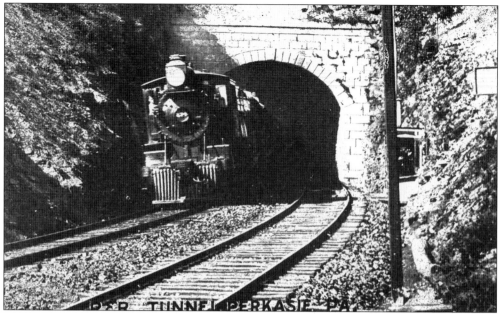

PERKASIE TUNNEL, C. 1900. At first only a single track went through the tunnel, but this slowed down train traffic. Double tracks were installed, making a very tight fit. One train engineer lost his head when he looked out of the engine before it had left the tunnel. Notice the watchman in his "box," whose job it was to stop anyone from entering the 2,200-foot tunnel. Because the tunnel has a slight curve one cannot see the other end when entering it, making it especially dangerous when many trains traveled through it each day.

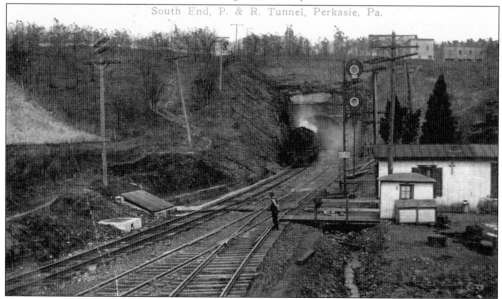

SWITCH AT PERKASIE TUNNEL, C. 1900. Switches allowed freight trains to be diverted to the freight station at Mount Alto and at the main Perkasie station. Mount Alto Coal and Lumber and Moyer's Lumber near Market Street used freight services. Steam from the engine needed to escape the long tunnel, so an exhaust hole was drilled from the top to the tunnel. (Hockman collection.)

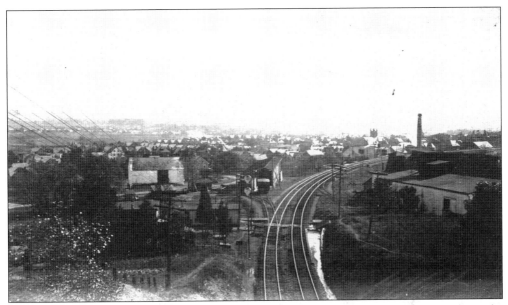

VIEW ON TOP OF TUNNEL, 1905. The photographer was on the edge of the ridge above the railroad tunnel when he took this panorama of Perkasie. He is probably standing about 100 yards or so from the steam exhaust hole. The large shed in the middle is Mount Alto Coal Company. It still stands today. The Perkasie Electric Company had a tall smokestack. It was taken down in 1963. (Perkasie Historical Society.)

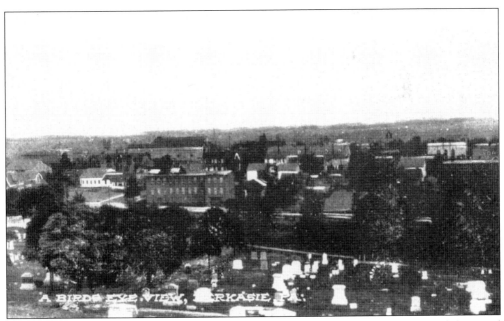

RIDGE ROAD AND MARKET STREET VIEW, 1925. The photographer was on solid ground when he took this bird's-eye view. He was at the top of the cemetery, near where Market Street meets the Ridge Road. Most of downtown Perkasie is seen. South Perkasie and the Mount Alto section are not shown. (Hockman collection.)

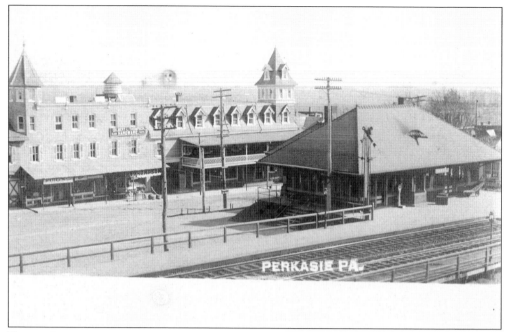

TRAIN STATION AND UNION HOTEL, C. 1910. This is the transportation hub of early Perkasie. Many hotels and stores were quickly built in the 1880s and 1890s when regular train service started. Only the train station has survived. The entire block across from the station was demolished during the 1960s with the urban renewal plan. (Hockman collection.)

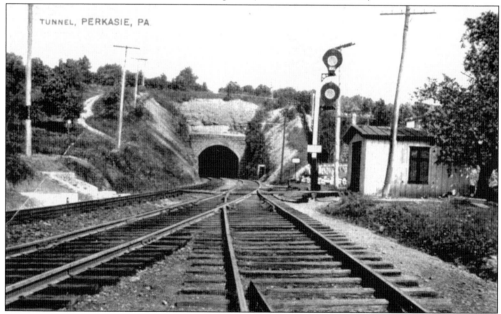

MODERN TRANSPORTATION AND COMMUNICATION, 1900. Today photographers try to avoid having telephone poles and power lines in photographs. But 100 years ago these were included as a source of civic pride. Perkasie was a town that got telephone service and electricity early despite being located in a rural area. Telephone service came to Perkasie in 1886 and electricity in 1898. From 1900 to 1947, Perkasie operated its own electricity power plant.

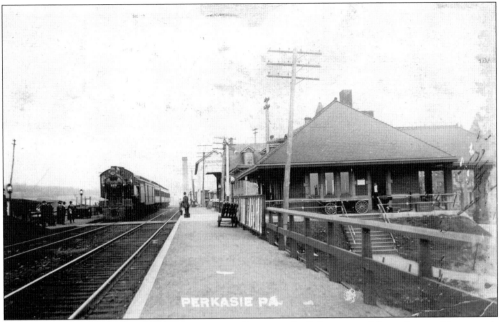

MAJOR PASSENGER SERVICE, 1880–1920. Perkasie was built because of the trains, and its growth depended on it. Trains, and later trolleys, connected rural Bucks County to Philadelphia and to the Allentown–Bethlehem area. Thousands of visitors come to Perkasie's resort and amusement parks each year. Hundreds of workers commuted to Perkasie's factories. The railroad line and station precipitated Perkasie's rapid growth. (Hockman collection.)

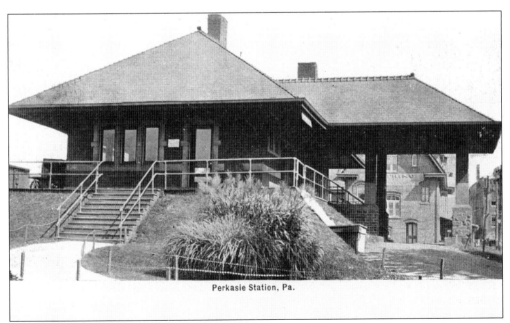

Perkasie Station, Pa.

PENNSYLVANIA AND READING STATION, PERKASIE. Compare this view of Perkasie's train station with how it looks now. The station's appearance has changed little. However, the buildings seen through its entryway were damaged due to the 1988 great fire.

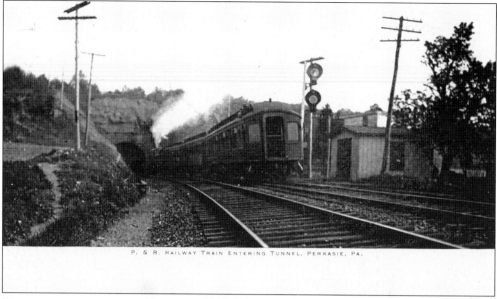

P. & R. RAILWAY TRAIN ENTERING TUNNEL, PERKASIE, PA.

NORTHBOUND THROUGH TUNNEL, 1903. The age of steam was also the height of Perkasie and Quakertown as transportation centers for upper Bucks County. Passenger trains stopped many times each day. The steam of locomotives could be seen for many miles away. Passenger rail service ended in 1980, with only occasional freight trains still operating.

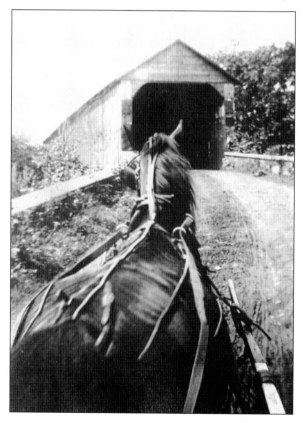

COVERED BRIDGE, 1900. Bridges were vital to Perkasie's transportation network, especially for South Perkasie, which had water on three borders. This unique photograph shows a horse and buggy about to use the covered bridge in South Perkasie. This was moved to Lenape Park in 1958 by the Perkasie Historical Society.

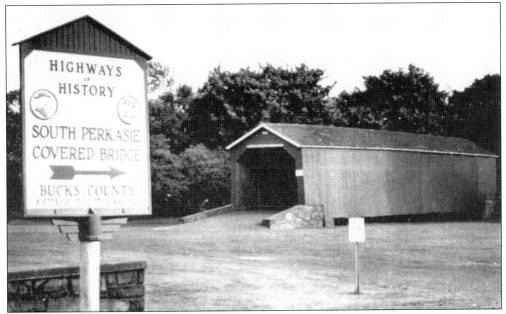

TODAY'S COVERED BRIDGE OVER LAND. In Lenape Park near the Walnut Street Bridge is a bridge that does not go over water. This is the former South Perkasie Covered Bridge that was moved for safekeeping in 1958. Many people travel to Perkasie to see this bridge as a historical artifact of early transportation and its unique location.

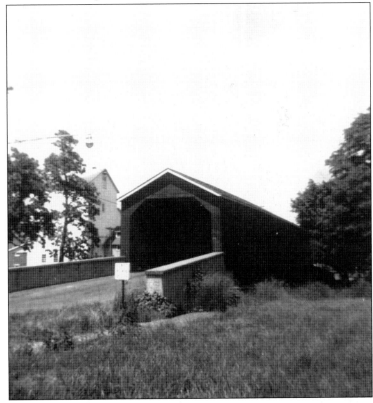

BRIDGE'S ORIGINAL LOCATION. Just before it was removed, the covered bridge was photographed where it had stood for 126 years, on Main Street in South Perkasie over the Pleasant Spring Stream. The former Savacool Mill still stands along the stream.

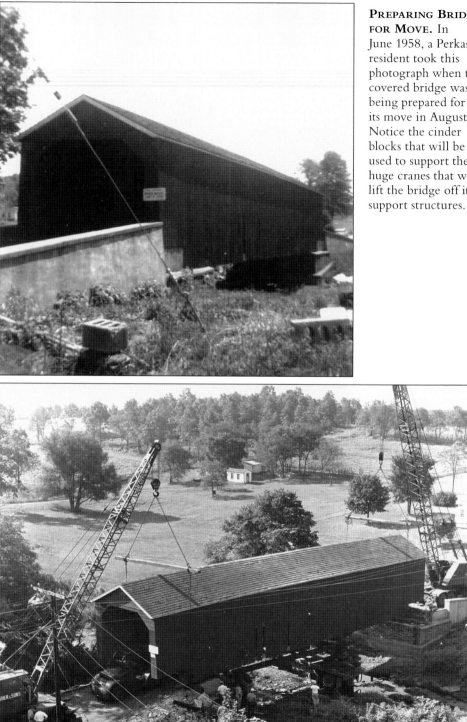

PREPARING BRIDGE FOR MOVE. In June 1958, a Perkasie resident took this photograph when the covered bridge was being prepared for its move in August. Notice the cinder blocks that will be used to support the huge cranes that will lift the bridge off its support structures.

BRIDGE MOVED, AUGUST 1958. On August 17, 1958, two huge cranes and a large workforce hoisted the covered bridge on its supports and readied the bridge for its half-mile journey to its new home in Lenape Park. (Perkasie Historical Society.)

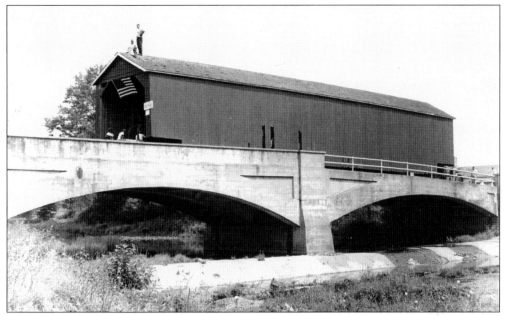

COVERED BRIDGE CROSSING WALNUT STREET BRIDGE. A large crowd watched as the covered bridge was slowly moved down Walnut Street toward Lenape Park. This remarkable photograph captures a very rare sight: a bridge going over another bridge. At this point, the covered bridge is only 200 yards from its new home. Immediately after crossing the concrete bridge there was a very sharp turn into the park for 50 more yards. (Perkasie Historical Society.)

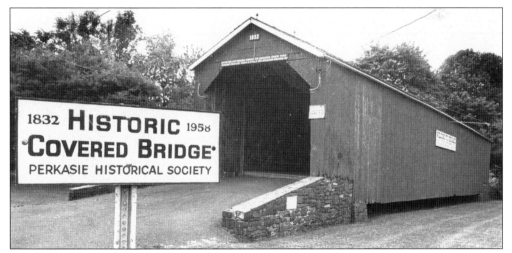

SAVED BRIDGE, LENAPE PARK. Written above the entrance is "1832 $5 fine for any person riding or driving over this bridge faster than a walk or smoking segars on." (Perkasie Historical Society.)

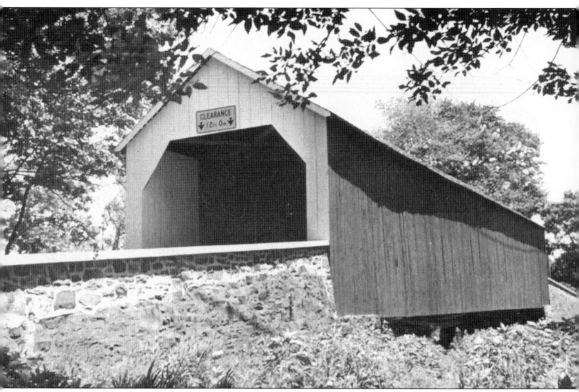

MOOD'S COVERED BRIDGE. On Blooming Glen Road bordering the southeast corner of Perkasie is Mood's Bridge. In 2004, it was destroyed by arson. It is being replaced with a copy of the original bridge. The only change will be fire-resistant wood and additional load support for the floor. The Pennridge community values its covered bridges. The rebuilt bridge in East Rockhill Township was rededicated in April 2008.

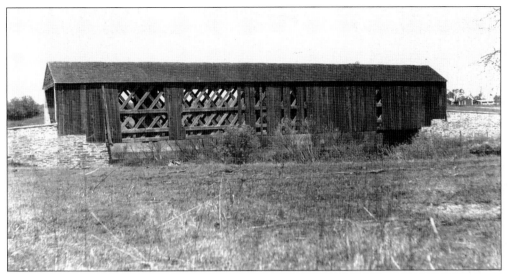

STEELEY'S COVERED BRIDGE, 1935, AND BRIDGE ACCIDENT, 1920S. These photographs show why many covered bridges did not survive the 20th century. Pictured above is Steeley's Covered Bridge, sometimes called the second covered bridge, which crossed the East Branch of the Perkiomen Creek. Covered bridges built in the 1800s for human and animal transportation often could not support the weight of motor vehicles, as seen in the photograph below, believed to be Steeley's Covered Bridge. Accidents and poor maintenance led to its replacement in 1937 with a steel and concrete bridge. It is located on Branch Road in East Rockhill Township. (Perkasie Historical Society.)

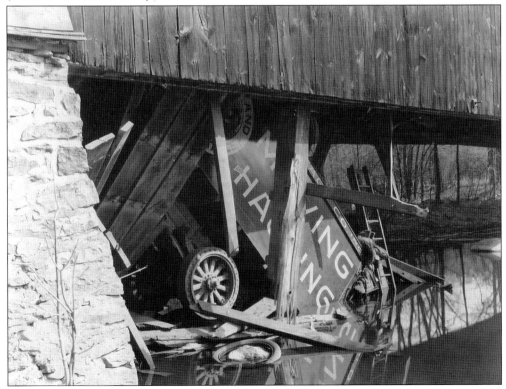

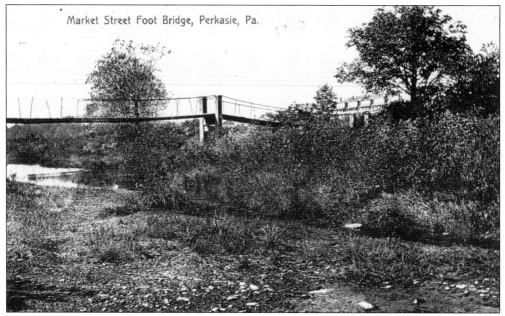

MARKET STREET FOOTBRIDGE. Only the Callowhill Street and Walnut Street bridges permit modern traffic between Perkasie and its Third Ward, South Perkasie. So footbridges such as the Market Street bridge seen here provide a shortcut for pedestrians. (Hockman collection.)

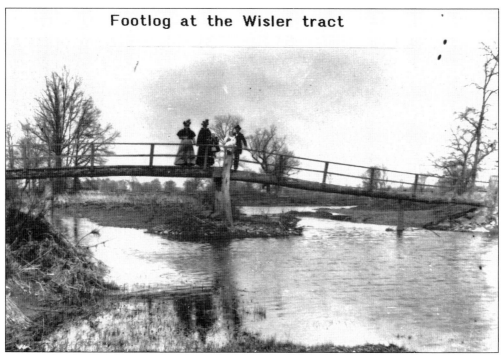

SOUTH PERKASIE FOOTLOG, 1905. This is a "homemade" bridge by the local residents in order to cross the Pleasant Spring Stream in South Perkasie. The Wisler family takes credit for building this unique log bridge. (Perkasie Historical Society.)

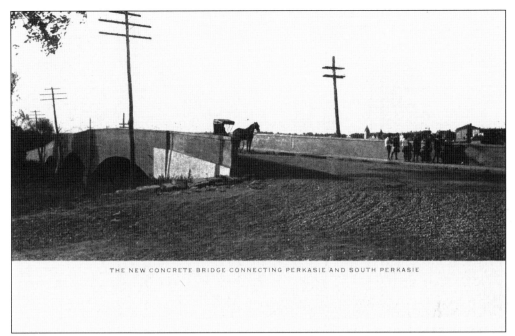

THE NEW CONCRETE BRIDGE CONNECTING PERKASIE AND SOUTH PERKASIE

PERKASIE CONNECTED TOGETHER. In 1902, Perkasie and South Perkasie were finally connected with a new concrete bridge. It is called the Walnut Street Bridge. This enabled people of South Perkasie to feel truly part of boomtown Perkasie. Access to Perkasie's train and trolley service became much easier.

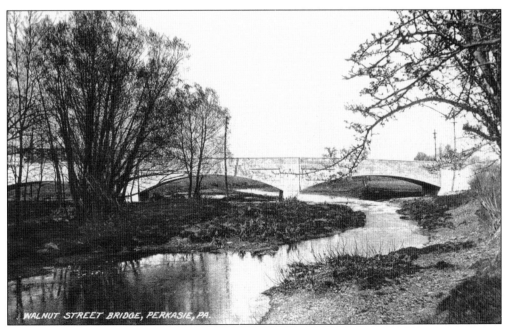

WALNUT STREET BRIDGE, PERKASIE, PA.

WALNUT STREET BRIDGE, 1905. A side view of this bridge shows that the area around the East Branch of the Perkiomen Creek had not been developed. Today there is an apartment complex, bank, Dairy Queen, and the moved covered bridge near this bridge.

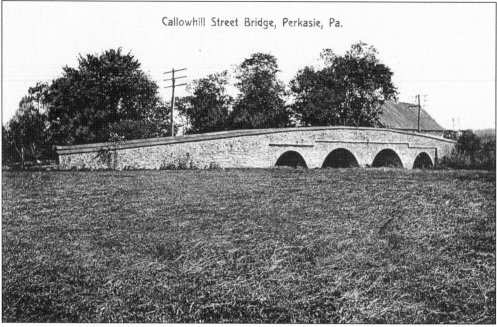

Callowhill Street Bridge, Perkasie, Pa.

CALLOWHILL STREET BRIDGE, 1908. This stone-arched bridge was built in 1881 over the Perkiomen Creek where Callowhill Street enters Hilltown Township. In 1948, this stone bridge was replaced by a wider concrete bridge still in use today. Convenience conquered beauty.

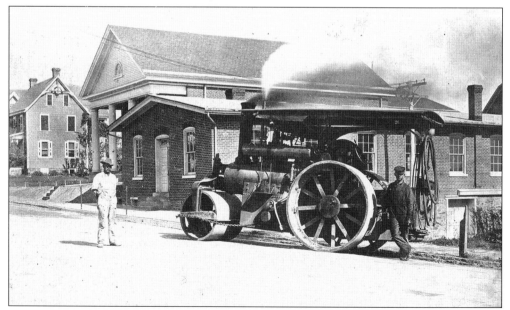

STEAMROLLING FOURTH STREET, C. 1910. Perkasie's early dirt streets needed to be steamrolled to reduce dust and mud when it rained or snowed. William Unfried, in the white shirt, is supervising the road construction. This work is being done on Fourth Street near Chestnut Street. The Perkasie Mennonite Church is the columned building. Gegan's Clothing factory is behind the steamroller. (Perkasie Historical Society.)

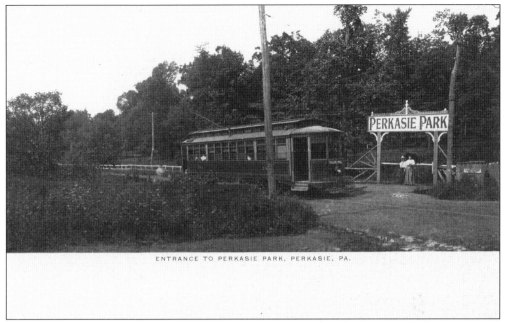

ENTRANCE TO PERKASIE PARK, PERKASIE, PA.

PERKASIE PARK TROLLEY SERVICE, 1903. Trolley service by the Quakertown Traction Company came to Perkasie in 1900 and was a big hit. Trolleys made travel easy and inexpensive between communities from Philadelphia to the Allentown-Bethlehem area. Many people came to Perkasie Park, a church-related summer retreat.

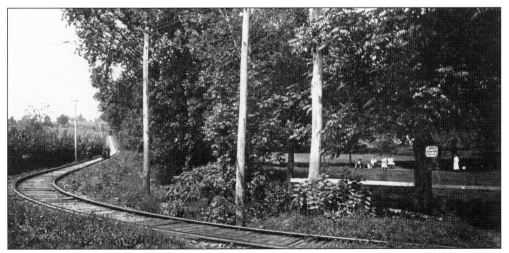

LIKE RUNNING THE BASES. This trolley is approaching Perkasie Park. Trolleys and train lines tried to avoid sharp turns. The trolley tracks are laid out like a baseball player running the bases. The "pretty" curve permits the trolley to maintain a safe speed. The speed of trolleys is surprising, sometimes reaching 50 or more miles per hour when between towns. However, Perkasie passed a law permitting only an eight-mile-per-hour speed limit.

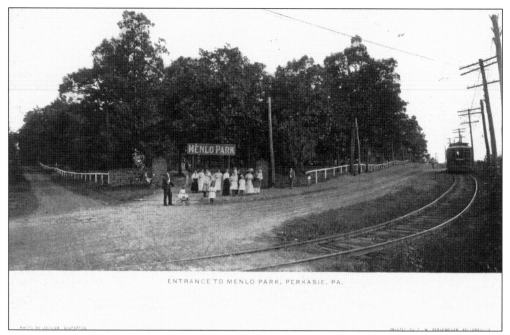

ENTRANCE TO MENLO PARK, PERKASIE, PA.

MENLO PARK'S TROLLEY SERVICE, 1902. Menlo Park was a trolley park, meaning that the park and the trolley line depended on each other for business success. Here the trolley is approaching the park entrance at Fifth Street and Park Avenue. The Quakertown Traction Company and the Inland Traction Company from Lansdale connected their trolley lines, making travel to Philadelphia and to Allentown easy. The two trolley companies merged into the Lehigh Transit Company in 1912. A Ninth Street overpass and a tunnel under the railroad line at Seventh Street going to its new station at Sixth and Walnut Streets were built. The owners of the Lehigh Valley Transit Company had a financial stake in Menlo Park until 1926. Thousands of visitors came by trolley to the park each summer. It cost a nickel to travel between Menlo Park and Perkasie Park.

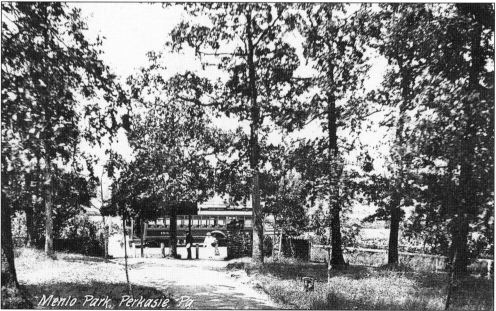

Menlo Park, Perkasie, Pa.

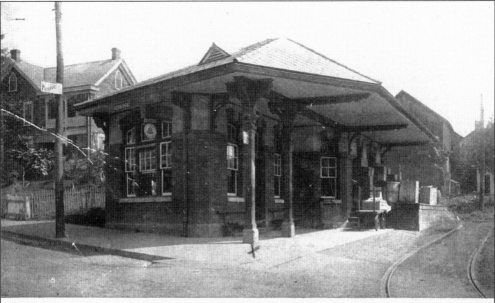

LEHIGH VALLEY TROLLEY STATION, Perkasie, Pa.

PERKASIE'S TROLLEY STATION, 1915. The Lehigh Valley Trolley Station was built in 1912 on Walnut Street, between Fifth and Sixth Streets. The trolley line traveling from Allentown to Philadelphia via Norristown was known as the Liberty Bell Line. The station was mainly for passenger service, but freight was also carried. The station was used until 1951 when the trolleys stopped running. Now the former station is the home of the Perkasie Historical Society. (Hockman collection.)

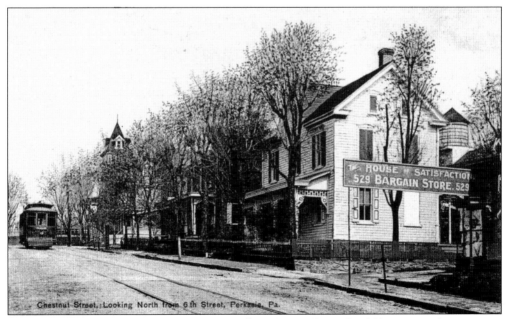

Chestnut Street, Looking North from 6th Street, Perkasie, Pa.

CHESTNUT STREET TROLLEY, 1910. Trolleys drove along the following Perkasie streets sometime between 1900 and 1951: Walnut, Chestnut, Market, Race, Fifth, Sixth, and Seventh Streets and Park Avenue.

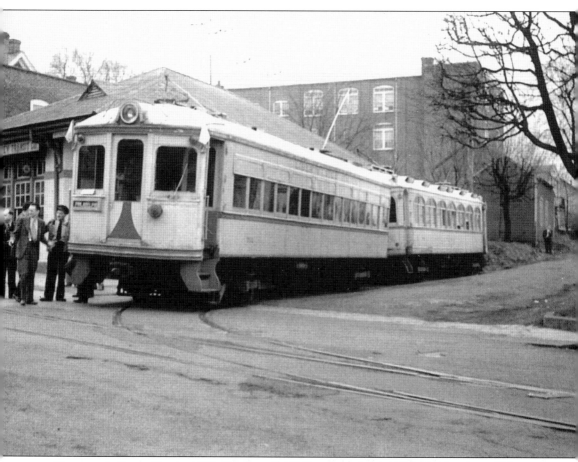

TROLLEY'S LAST RIDE, 1951. During the 1930s, the public's riding habits changed because the automobile became the favored means of travel. There was a brief revival of trolley use during World War II due to gas rationing and to a shortage of car equipment. After the war, traveling by trolley declined as the car became the king of transportation. Some automobile manufacturers acquired trolley companies and neglected their upkeep. In September 1951, the Liberty Bell Line made its last run through Perkasie; 51 years of trolley service ended. (Perkasie Historical Society.)

Two

ACTIVE AND ATTRACTIVE

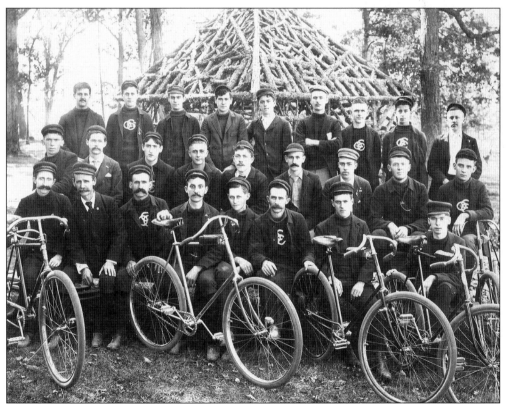

PERKASIE BICYCLE CLUB, C. 1905. Perkasie's boom years paralleled when leisure time was increasing for most people. Recreational activity such as sports, amusement parks, and vacations became part of people's lives. Riding bicycles became popular. Menlo Park had a one-third-mile bicycle track. The Perkasie Bicycle Club took day trips to other neighboring towns. (Perkasie Historical Society.)

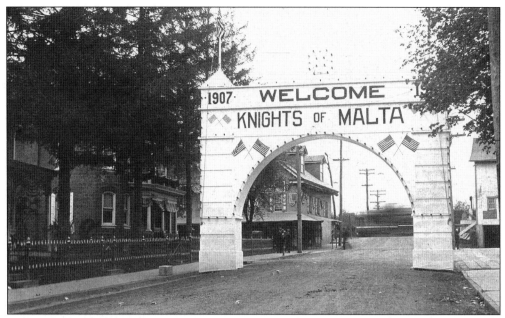

CONVENTION WELCOMING ARCH, 1911. Fraternal lodges were an important part of Perkasie's social life. Perkasie was just 32 years old as a town when it hosted the state convention for the Knights of Malta in 1911. One reason why Perkasie was able to host a large convention is seen through the welcome arch. A speeding train represents Perkasie as a transportation center. Conventioneers could come from across Pennsylvania by train or trolley or "modern" roads. (Perkasie Historical Society.)

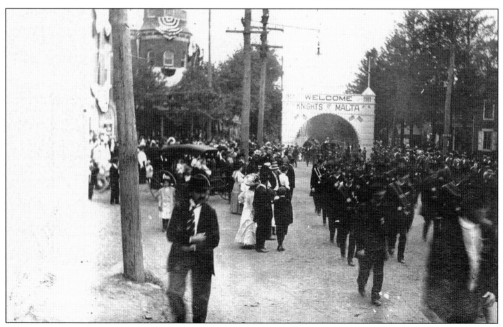

CONVENTION PARADE, 1911. A large crowd watches the Knights of Malta delegates march up Market Street toward Seventh Street. Perkasie could house large groups with its many hotels, most within two blocks of this parade route. (Hockman collection.)

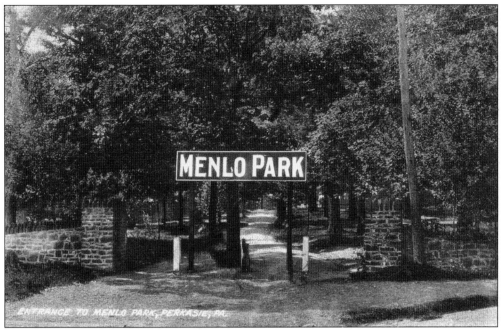

ATTRACTIVE MENLO PARK, 1900. In 1929, Perkasie's 50th anniversary slogan was Perkasie—Active and Attractive. That would correctly describe Perkasie from the 1890s through to the 1940s, when it was a major summer retreat and amusement center. Menlo Park was founded in 1892 by businessmen Samuel Kramer, Grier Scheetz, and Isaac Groff. The park started with a picnic grove, boat rides, and a carousel. In a few years, it would be a well-known amusement park.

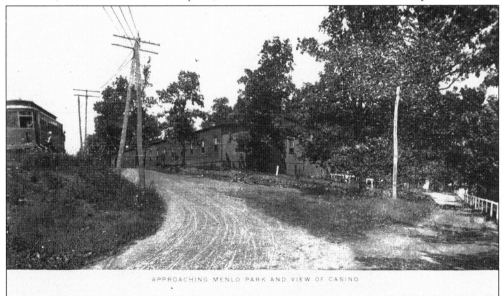

TROLLEY STOP AT CASINO, 1907. Trolleys brought visitors to the front door of the casino, helping to make it the social center of Menlo Park. Built in 1907, the casino did not have gambling, rather it had activities for all ages. The casino was demolished in the mid-1960s. The Pierce Library is located on much of the casino's former location. Today's water park is located behind the casino site. The path on the right leads to the carousel and the former site of the toboggan.

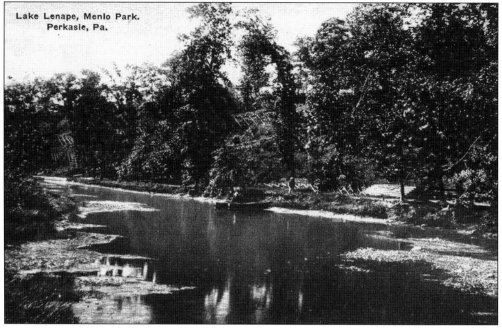

LAKE LENAPE, MENLO PARK, 1920. Lake Lenape is the part of the East Branch of the Perkiomen Creek that flows through Perkasie's Menlo Park. Boating was a common activity for Menlo Park visitors. Look carefully between the trees, portions of the toboggan tracks can be seen.

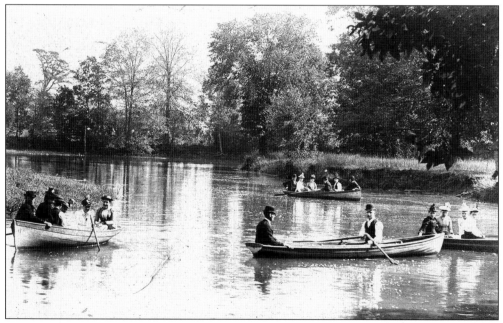

LAKE LENAPE'S BOATING "HEAVEN." This *c.* 1905 photographic postcard supports Menlo Park advertisements that Lake Lenape was ideal for city visitors to boat: "the boating grounds are a full mile in length, and the water is at no place more than four feet in depth, making it perfectly safe for excursionists."

INSIDE MENLO PARK, 1900. This view faces the entrance to the park. The pump house is the structure with an arbor. The white fence seen beyond the trees is along Park Avenue.

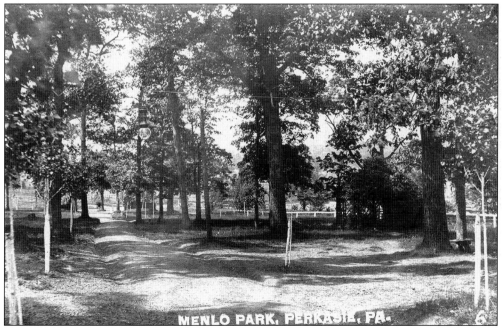

WATER PUMP, MENLO PARK. The pump house provided fresh well water to park visitors. It was a popular place to be photographed. The walk path leads to the park entrance at Fifth Street and Park Avenue.

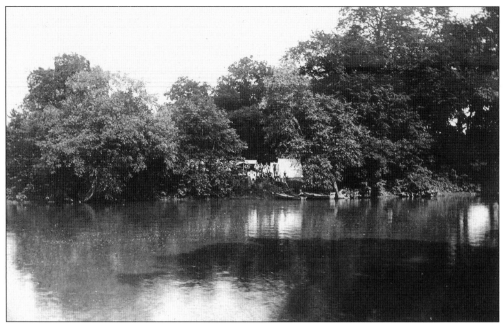

CAMPING AT LAKE LENAPE, 1900. Camping out was a popular leisure activity. Boy and Girl Scouts, families, and city dwellers all enjoyed camping in Menlo Park along Lake Lenape.

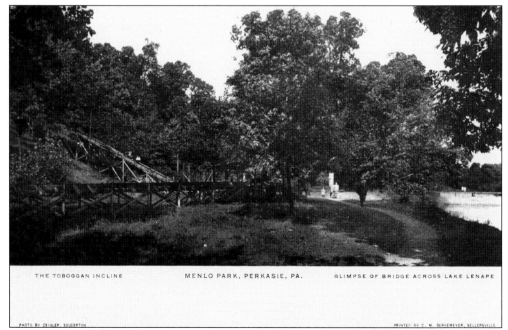

THE TOBOGGAN INCLINE MENLO PARK, PERKASIE, PA. GLIMPSE OF BRIDGE ACROSS LAKE LENAPE

PHOTO BY ZEIGLER, SOUDERTON PRINTED BY C. M. BERKEMEYER, SELLERSVILLE

THREE ATTRACTIONS, 1903. This postcard shows three attractions that brought thousands to Menlo Park and its Lake Lenape every year. From left to right are a toboggan car seen going down the tracks, a walking path along Lake Lenape, and people walking across the park bridge.

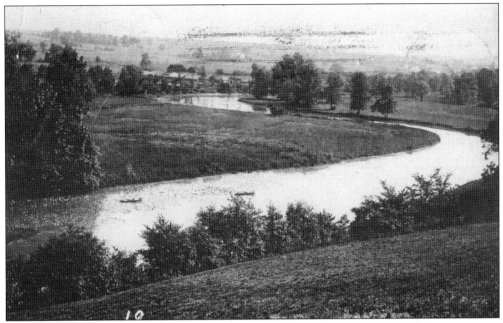

DEVIL'S BEND, LAKE LENAPE. This part of Lake Lenape is entering the borough of Sellersville. One could boat from Menlo Park, Perkasie, to Sellersville's milldam. A small steam excursion boat traveled along this waterway. (Hockman collection.)

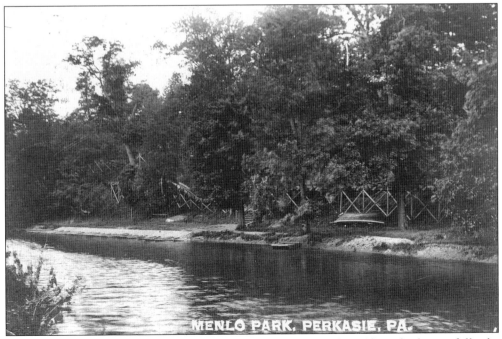

BOATING AND TOBOGGAN, 1900. There is another view where if one looks carefully the toboggan tracks can be seen. In 1902, the Lehigh Valley Traction Company (trolleys) bought Lake Lenape as an attraction for people to ride its trolleys to Perkasie's Menlo Park and Lake Lenape. (Hockman collection.)

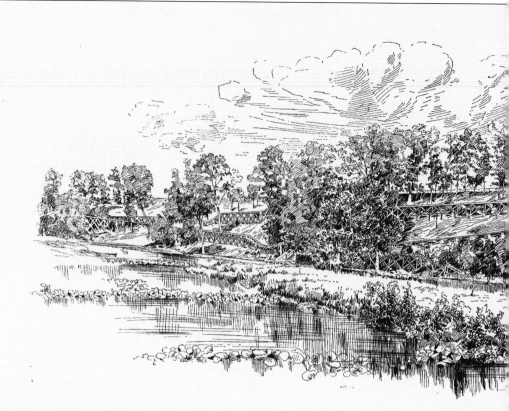

THE WONDERFU

PERKASIE'S FAMOUS TOBOGGAN RIDE. The "wonderful mountain schute" was also called the toboggan. This rare drawing shows the entire Menlo Park Toboggan route down the hill. When it first operated in 1894, it was recognized as the longest amusement ride of its kind in the

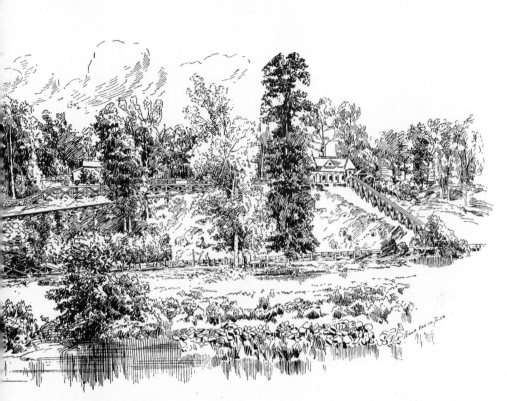

UNTAIN SCHUTE.

world. The half-mile ride down was powered by gravity, except for the ride back up the hill. A 25-horsepower steam engine pulled the cars back up the hill to the start. The tracks zigzagged in a figure eight along the steep ridge until stopping along Lake Lenape.

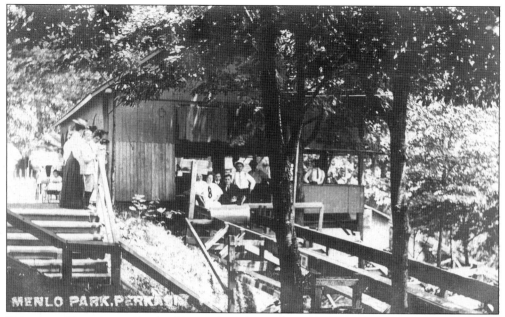

START OF TOBOGGAN RIDE, 1900. The toboggan ride was the most popular attraction in Menlo Park. It was a forerunner of the modern roller coaster. People would come from long distances to ride the toboggan. More than 6,000 passengers rode the toboggan on one August 1894 day. It was reported that one couple loved the ride so much that they stayed on it an entire day and rode more than 40 trips. (Hockman collection.)

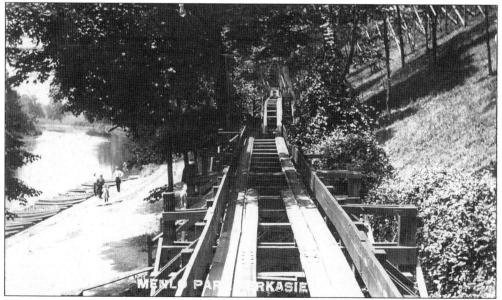

TOBOGGAN'S WOODEN TRACKS, 1900. Despite its great popularity, the toboggan had safety problems. Its construction of wood led to the feeling of a "flimsy shaky toboggan," and its side guardrails were low. But the major safety issue was vandalism or sabotage. There were several incidences where mischievous young men put large rocks on the tracks, causing serious accidents. An 1895 accident resulted in a successful lawsuit against the owners of the toboggan. (Hockman collection.)

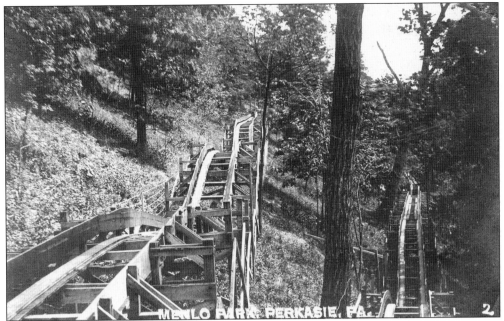

TOBOGGAN'S ZIGZAG, 1900. This photographic postcard shows the zigzag path of the toboggan as it went down the steep hillside next to Lake Lenape.

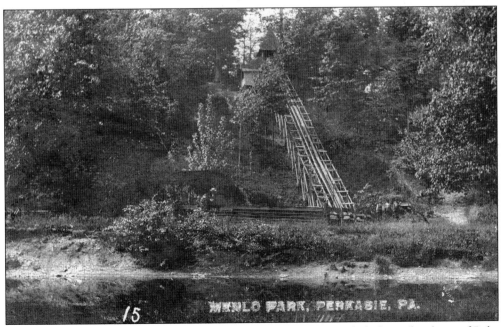

TOBOGGAN'S RETURN INCLINE, 1900. The toboggan ride ended along the shore of Lake Lenape just below the ride's starting point. The ride start building and the engine house can be seen at the top of the ridge.

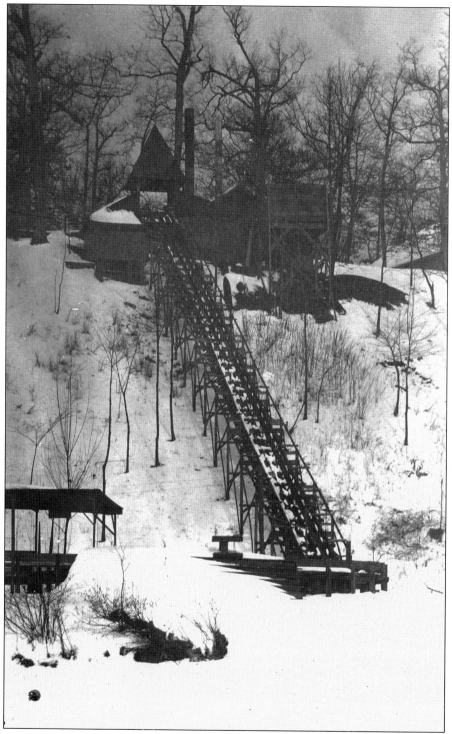

WINTER VIEW OF TOBOGGAN INCLINE, 1905. A 25-horsepower steam engine pulled the toboggan cars back up the steep incline. The steam engine also ran the carousel that was housed in the building seen just beyond the toboggan start. (Hockman collection.)

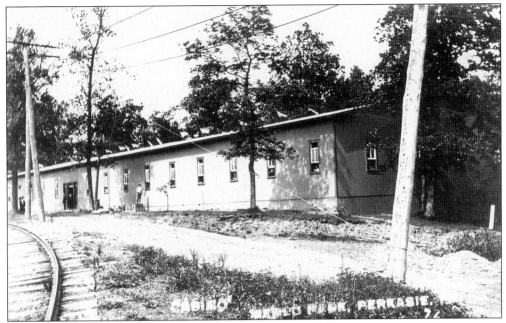

MENLO PARK'S CASINO, 1910. No gambling, but the largest building of the Menlo Amusement Park had a roller-skating rink, a refreshment stand, a bowling alley, and a small motion picture theater. The casino was demolished in the mid-1960s. The Pierce Library now stands at this location. (Hockman collection.)

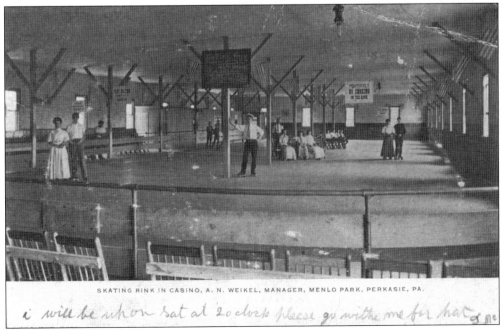

SKATING RINK IN CASINO, A. N. WEIKEL, MANAGER, MENLO PARK, PERKASIE, PA.

i will be up on Sat at 2 oclock please go with me for that

CASINO'S ROLLER-SKATING RINK, 1907. Roller-skating was a popular social activity while getting some exercise. It was a "proper" physical activity that men and women could do together.

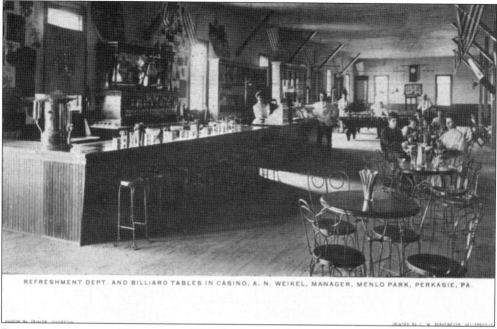

REFRESHMENT DEPT. AND BILLIARD TABLES IN CASINO, A. N. WEIKEL, MANAGER, MENLO PARK, PERKASIE, PA.

REFRESHMENTS AND BILLIARDS, 1903. Look carefully at this postcard for all the activities in this part of Menlo Park's casino: soda foundation, pool tables, eating, and socializing.

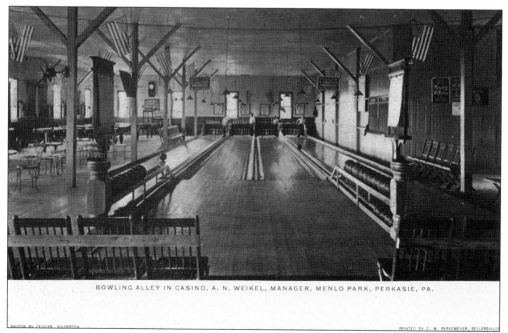

BOWLING ALLEY IN CASINO, A. N. WEIKEL, MANAGER, MENLO PARK, PERKASIE, PA.

CASINO'S BOWLING ALLEYS, 1903. Notice the pin boys who would reset the pins and return the bowling ball to the players. There is a diagram of the bowling pins behind them on the wall. The pin boy would use the diagram to let the bowler know which pins were still standing. Notice on the right-hand wall the signs for "moving picture" with "admission 5 cents."

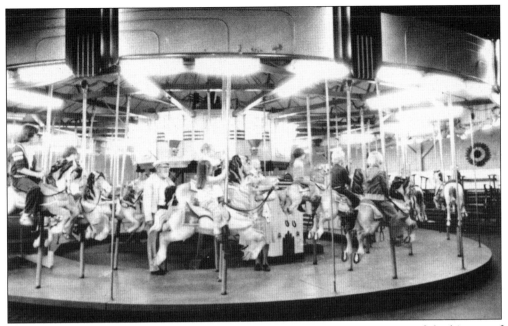

PERKASIE'S MODERN CAROUSEL, 1975. A carousel ride has been a part of the history of Perkasie's Menlo Park since it started in the 1890s. In 1895, a carousel was rented during the summer and put under a big tent. The next year, the park purchased the carousel and built it a permanent home that is still used today. The carousel is now owned and operated by the Perkasie Historical Society.

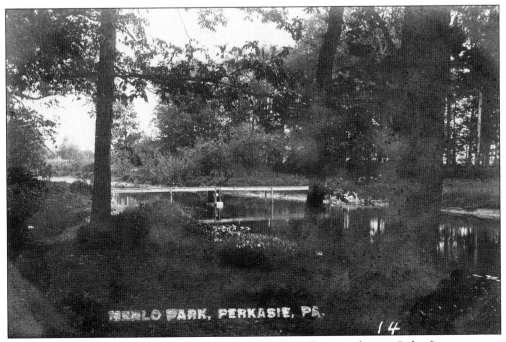

FOOTBRIDGE, MENLO PARK, 1910. Quiet walks along and over Lake Lenape were free activities.

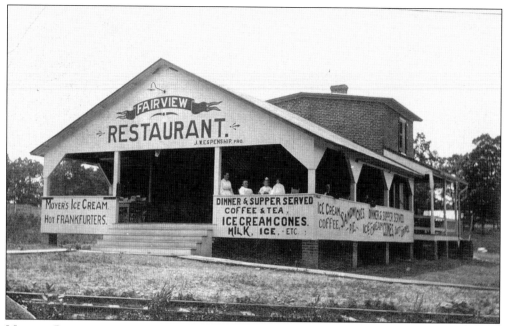

MENLO PARK EATERY, C. 1910. Hundreds and sometimes several thousand people visited Menlo Park each summer day and were fed at pavilions like this one. Some sources state that this building also had a roller-skating floor. The best historic guess is that this structure was demolished during the 1920s. (Hockman collection.)

PERKASIE PARK, PRIOR TO 1900. This photograph had to be taken before 1900 when trolleys came to Perkasie Park. Perkasie Park was started as a church retreat and camp in 1875, chartered to the Evangelical Church. The park is located along Ninth Street, west of Chestnut Street. Today the cabins are still used for family vacations. Today it is operated by the United Methodist Church.

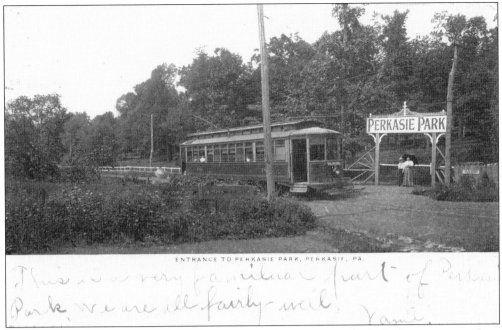

ENTRANCE TO PERKASIE PARK, PERKASIE, PA.

This is a very familiar part of Perkasie Park, we are all fairly well. Yours,

PERKASIE PARK TROLLEY SERVICE, 1903. People came to Perkasie Park to get away from the heat, smell, and congestion of Philadelphia and other cities. Church retreats were popular during this time. The country parks were believed to help improve people's moral and spiritual makeup because they were away from the corrupting influence of city life. The better quality of air was also desired by city residents who came to Perkasie.

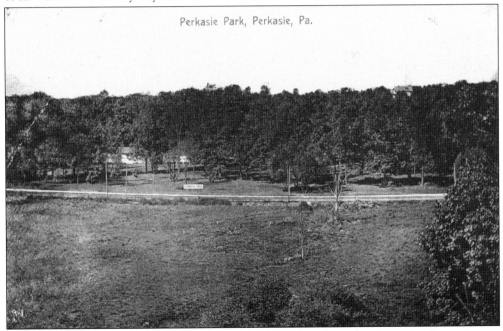

Perkasie Park, Perkasie, Pa.

ENTIRE VIEW OF PARK, 1910. This photograph was taken from the elevated train tracks near the Stout Cemetery at Eighth and Walnut Streets. Perkasie Park is on a 35-acre lot. Cottages, a dining hall, an auditorium, and a dormitory were built during its long history.

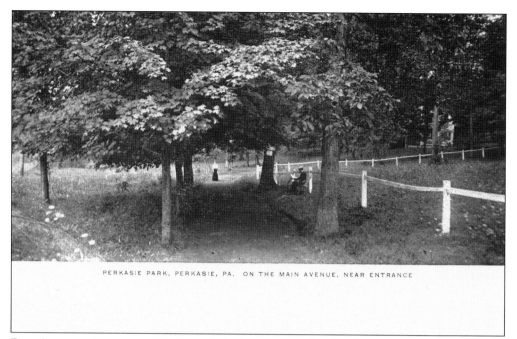

PERKASIE PARK, PERKASIE, PA. ON THE MAIN AVENUE, NEAR ENTRANCE

PARK'S MAIN AVENUE, 1903. Perkasie Park was a church-related park. It was used for family summer retreats, camp meetings, and Christian education events during the 1930s and as a retreat for teenagers during the 1940s. The park has kept its countryside environment despite having Perkasie grow around its property.

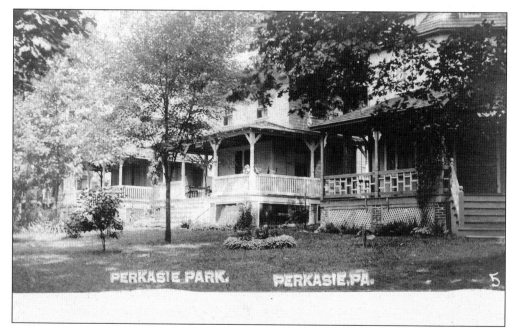

FAMILY COTTAGES, 1910. The erection of cottages started in 1886. Today there are 60 cottages in Perkasie Park. Families own their cottages and rent the land, which is owned by the Perkasie Park Association. The park is open from mid-April to mid-October. Most cottages are not heated, originally as a safety issue. In 1900, a fire destroyed 19 cottages. All were rebuilt.

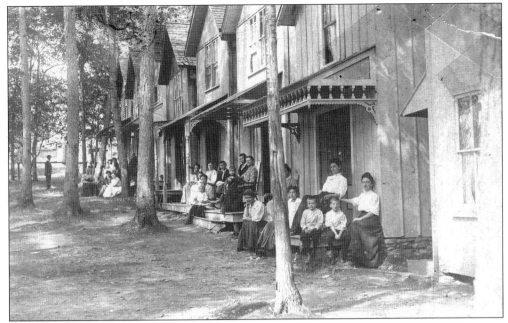

PERKASIE PARK RESIDENTS, 1910. Some families who have cottages today in Perkasie Park can trace back to relatives who were original campers in the 1880s. As seen in this early postcard, the park is for family summer retreats. The athletic association conducts most of the park's social events.

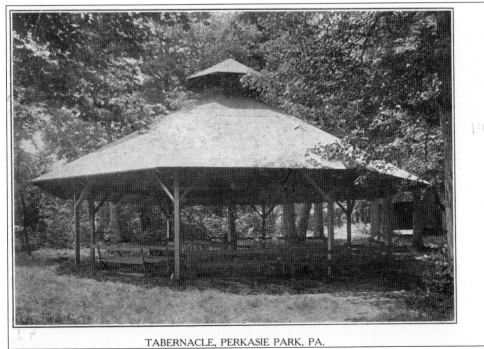

TABERNACLE, PERKASIE PARK, PA.

TABERNACLE, PERKASIE PARK. Christian fellowship has been the focus of Perkasie Park since it opened in the 1880s. This small tabernacle was used for camp meetings. (Hockman collection.)

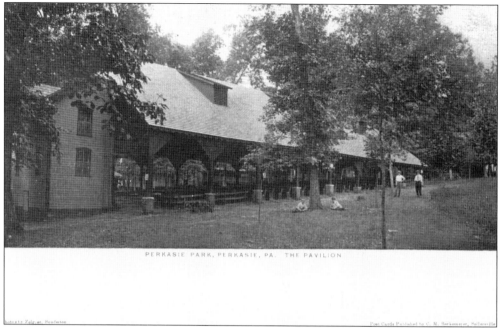

PERKASIE PARK, PERKASIE, PA. THE PAVILION

LARGE PAVILION, 1903. This auditorium has a seating capacity of 600. It was built in 1884 and expanded in 1892. Large church camp meetings were held here. The pavilion is still standing today, used for summer church services and park activities.

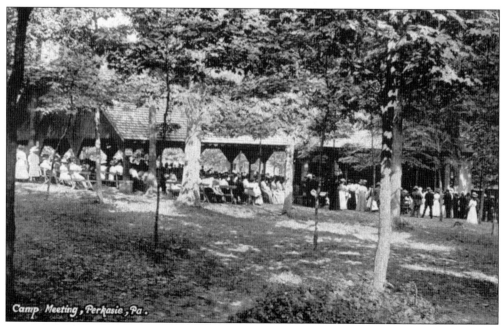

Camp Meeting, Perkasie, Pa.

CAMP MEETING IN PAVILION, 1911. The Evangelical Church first operated Perkasie Park. Today the United Methodist Church runs the park. The days of camp meetings are gone, but the natural beauty and serenity of the park continues today. Families come each summer to use their cottages.

Three

WORK, BUSINESS, AND INDUSTRY

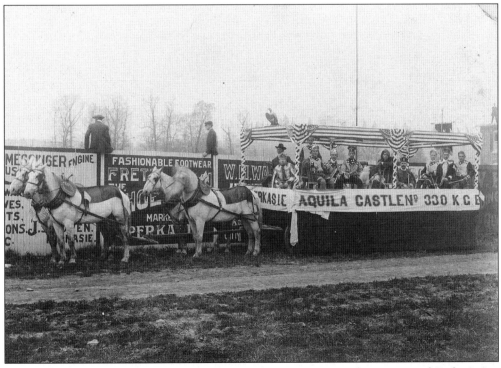

PERKASIE BUSINESS ADVERTISEMENTS GALORE! Businesses make towns, and Perkasie is a prime example. While this *c.* 1913 photograph postcard shows a parade float for the Knights of the Golden Eagle Lodge, the fence is plastered with Perkasie business advertisements. (Hockman collection.)

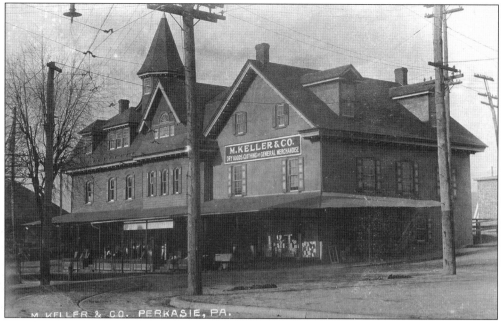

FIRST COMMERCIAL BUILDING. Samuel Hager built this building in 1871 as a business venture. He hoped that the railroad would make it a stop on the North Penn line. It did not, and Hager had to sell the building. It was then called the Hendricks Building. This *c.* 1905 photograph postcard shows that M. Keller and Company was operating it. (Hockman collection.)

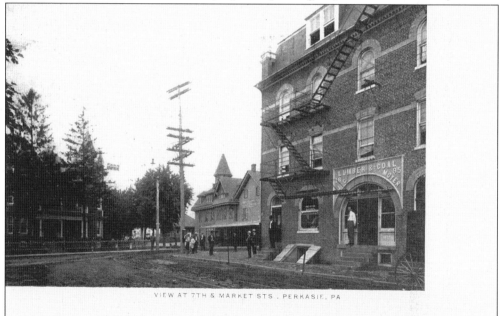

COMMERCE CENTER, 1903. The intersection of Seventh and Market Streets has been the center of commerce since Samuel Hager built his store and train depot in 1871 (later called the Hendricks Building), seen in the center of the picture. The Moyer Building is on the right. It was a multiple-use building with train freight, stores, and factories. Only a restored Hendricks Building has survived the 1988 great fire and 1960s urban renewal.

WHERE PERKASIE STARTED. Perkasie started as a business venture along the railroad tracks at Seventh Street between Chestnut and Arch Streets. Neamand's drugstore, Perkasie's first, was located in the small white building in the middle of this postcard. Today it houses Bucks County Vision Center at Seventh and Chestnut Streets. Early buildings seen from left to right are the train station, Neamand's, Union (Meyer's) Hotel, and the Perkasie First National Bank.

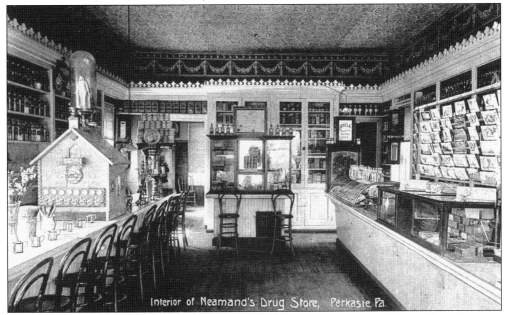

INTERIOR OF NEAMAND'S DRUGSTORE, *C.* 1910. According to Donald K. Lederach, Harry Neamand, a college-trained pharmacist, started his business in November 1894. Perkasie's first soda fountain was in this drugstore. Neamand's home remedies, Dr. Kriess's headache tablets, Chicken-Salve, and other well-known preparations of the time were developed and made by Neamand here.

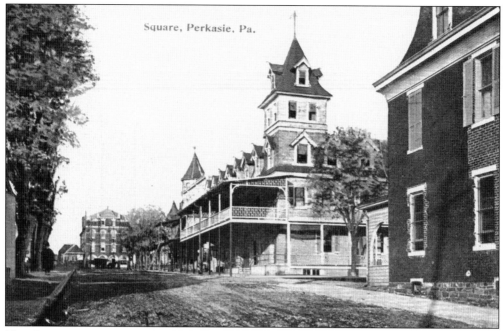

THE BUSINESS SQUARE, 1910. The early business center ran along Seventh Street and Chestnut to Arch Streets. The train station is off to the left. Seen from left to right are the J. G. Moyer Building, storefronts, the Union Hotel, and the First Perkasie National Bank.

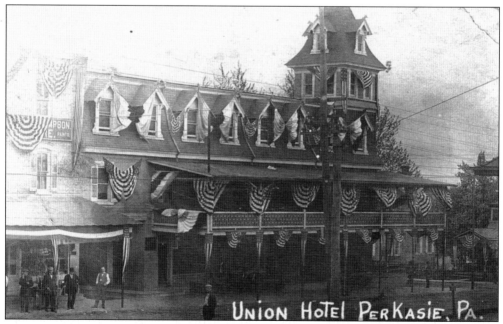

DECORATED UNION HOTEL, 1911. The Union Hotel, sometimes called the Meyer's Hotel, was located directly across from the train station. In this rare photograph postcard, the Union Hotel is decorated, most likely for a convention such as the 1911 Knights of Malta. The hotel's tall steeple could be seen by train passengers as they approached Perkasie. (Perkasie Historical Society.)

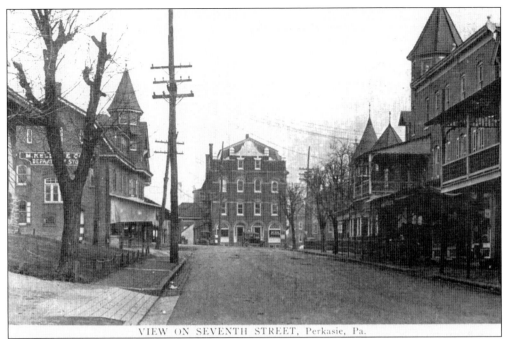

VIEW ON SEVENTH STREET, Perkasie, Pa.

SEVENTH STREET BUSINESSES. Taken in front of the train station, this postcard gives a close-up of the buildings that made up the commercial hub of Perkasie from the 1890s to the 1950s. This scene is similar to a 1946 *Saturday Evening Post* cover painting.

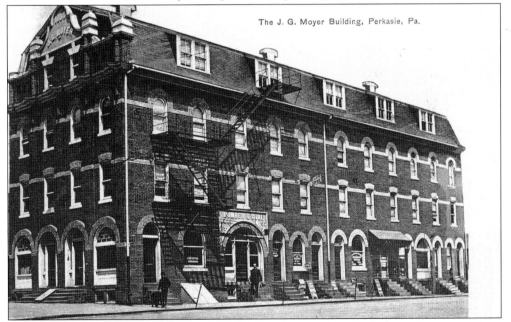

The J. G. Moyer Building, Perkasie, Pa.

J. G. MOYER BUILDING, 1909. Joseph G. Moyer started a lumber and coal business along the train tracks at Seventh and Market Streets. Along with Samuel Hager, Joseph Moyer was a founder of Perkasie. He moved to Comleyville, Perkasie's first unsuccessful name, in 1870. His building had various business enterprises as tenants along with his own business. J. G. Moyer was the most prominent building in town until it was destroyed during the 1988 great fire.

51

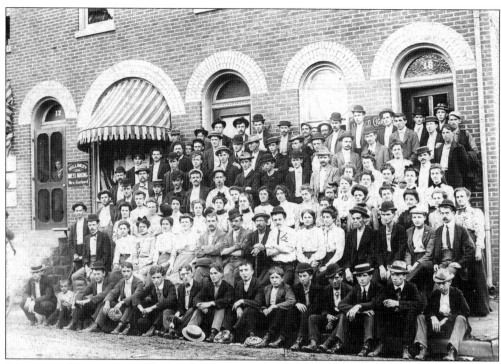

MILLINERY WORKERS, MOYER BUILDING. One of the businesses in the J. G. Moyer Building was a millinery, making women's dresses. This photograph was taken outside the factory along Seventh Street. Notice the number of men working at this craft. (Perkasie Historical Society.)

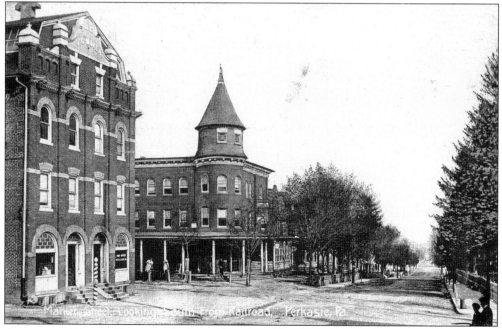

AMERICAN HOUSE CORNER. At Seventh and Market Streets also stood the large American House, a hotel and bar. This view was taken looking south down Market Street from the railroad tracks.

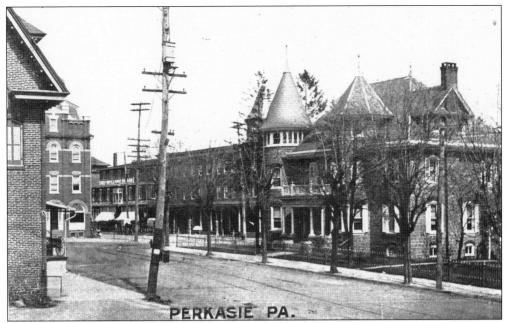

MANSION, SEVENTH AND MARKET STREETS, 1910. Perkasie lost one of its great Victorian mansions when the mansion at Seventh and Market Streets was demolished in 1964 for urban renewal. With its two cupolas and dark granite exterior, it represented Perkasie's boomtown days of successful businessmen being able to build a mansion for their family.

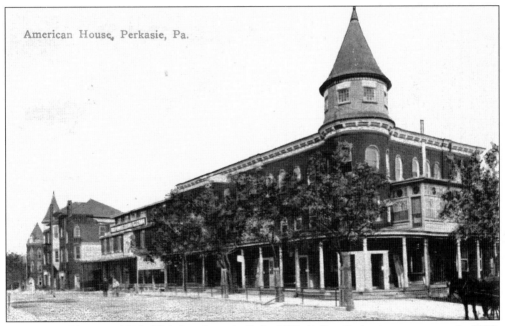

AMERICAN HOUSE, 1903. This hotel was built in 1870, before Perkasie was a town. In 1882, Philip Cressman became the owner-operator. This hotel and restaurant was a major landmark until it was destroyed by the great fire of 1988. Also seen is Kulp Brothers Bazaar (store) and the Cressman Lodge hall.

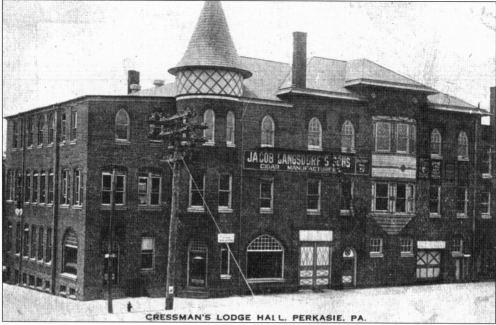

CRESSMAN'S LODGE HALL, PERKASIE, PA.

CRESSMAN'S LODGE HALL. This building was Perkasie's largest when it was built in 1897, located at Seventh and Arch Streets. At first it housed cigar manufacturing, the first home of Perkasie's fire company, and a livery stable and was the meeting place for many of Perkasie's fraternities and sororities. When it was enlarged several stores were added. The Harmonic Band stored its instruments here. It was totally destroyed by a major fire in November 1922. In 1924, the current storefront structure was built at the same location. (Hockman collection.)

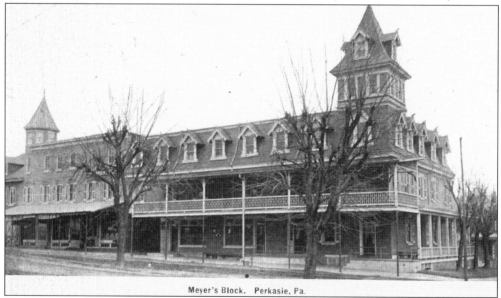

Meyer's Block, Perkasie, Pa.

THE MEYER'S BLOCK, 1912. Businesses often changed owners and locations during Perkasie's rapid growth. Here is the hotel at Seventh and Chestnut Streets called Meyer's Block, then Moyer's Block. Finally the name Union Hotel was established until this structure was demolished in 1967.

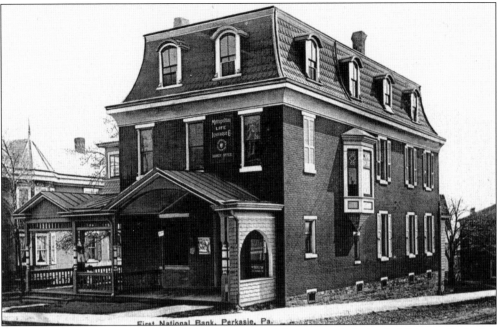

THE FIRST NATIONAL BANK, C. 1910. A commercial town needed a bank. This was Perkasie's first established bank located at Seventh and Chestnut Streets. It was replaced in 1922 by the bank building seen below.

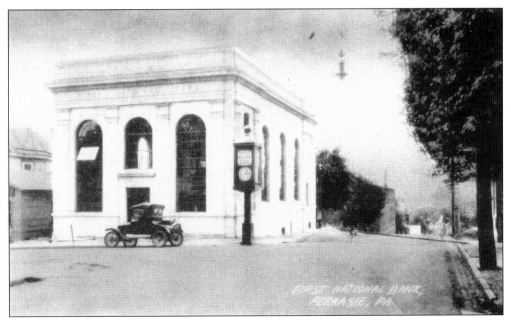

NEW FIRST NATIONAL BANK, 1925. This replaced the Victorian house that served as Perkasie's first bank. It became Bucks County Bank for much of its modern history. After more than 50 years of service, this bank was sold to Perkasie Borough. It was renovated into the current borough office. (Hockman collection.)

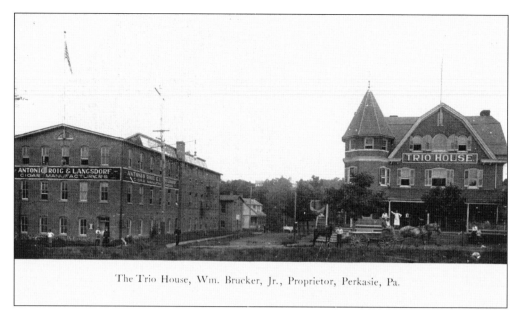

The Trio House, Wm. Brucker, Jr., Proprietor, Perkasie, Pa.

HOTEL, FACTORY, AND RAILROAD, 1903. The Trio House, Eighth and Chestnut Streets, was a major hotel serving train passengers. Antonio Roig and Langsdorf Cigar Manufacturing employed both Perkasie residents and workers who commuted to Perkasie by train or trolley, both having stops within 50 yards.

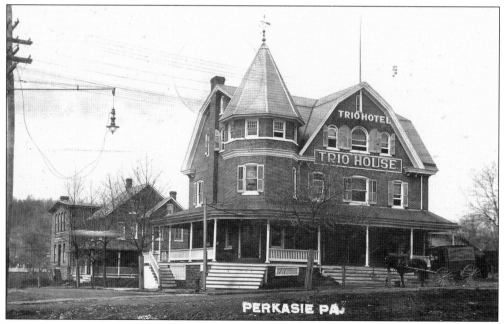

TRIO HOUSE HOTEL, 1914. Perkasie had several boardinghouses like the Trio House. Perkasie had early electric streetlights. The building at left is a clothing factory. By 1920, clothing manufacturing had surpassed cigar making as the major industry of Perkasie.

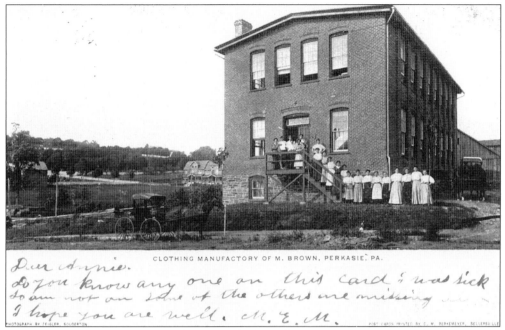

Dur Annie.
Do you know any one on this card i was sick
so am not on some of the others are missing —
I hope you are well. M. E. M.

CLOTHING FACTORY, 1903. This small clothing factory was located on Chestnut Street, between Eighth and Ninth Streets. In more recent years, the building served as the Pennridge Senior Center until it moved to Silverdale. In the distance the row houses along Market Street can be seen. The open field will be the future location of the Perkasie Mausoleum and modern row homes.

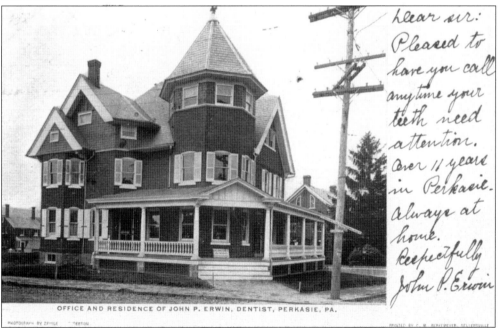

Dear sir:
Pleased to
have you call
anytime your
teeth need
attention.
Over 11 years
in Perkasie.
Always at
home.
Respectfully
John P. Erwin

DENTIST OFFICE AND HOME, 1905. Prosperous Perkasie attracted professional services such as dentists and doctors. Dentist John Erwin is using a postcard of his house and dentist office for advertising. Today a law office occupies this building at Fifth and Market Streets.

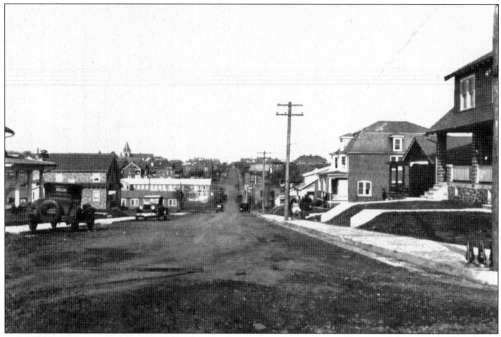

Snyder Cigar Factory, Fourth Street. Cigar manufacturing was the major industry of Perkasie from the 1880s to the 1920s. The last cigar factory closed in the 1950s. The Snyder Cigar Factory is the long building in the middle. (Hockman collection.)

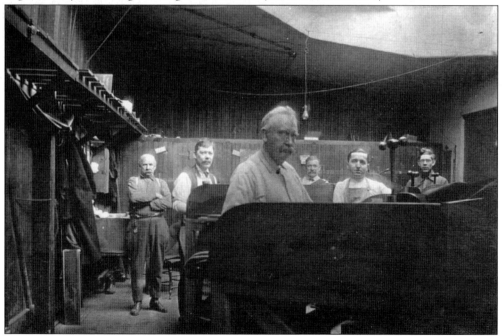

Cigar Box Factory, c. 1905. Cigar making had three major steps: preparing the leaves for use, rolling the cigar, and molding and boxing them. This photograph shows workers in a cigar box factory. Perkasie had several. Determining the location of cigar manufacturing is a challenge because these businesses moved and changed ownership often. (Perkasie Historical Society.)

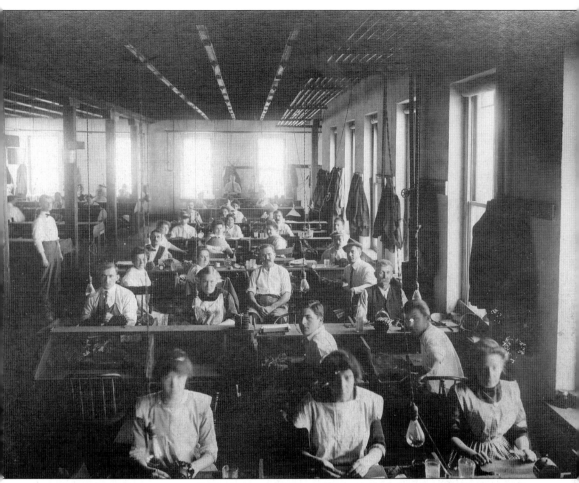

CIGAR-MAKING FACTORY, C. 1905. Cigar making was big business in Bucks and Montgomery Counties from the 1880s to the 1920s. Nearly half the population of Perkasie in 1895 was employed in cigar factories or held a job strongly related to cigars, such as shipping or accounting. Cigars were made in large and small factories and sometimes in homes by the entire family as piece work. Names of owners and operators of Perkasie cigar manufacturing include Boltz, Clymer and Company, Eisenlohr Brothers, Hegeman, H. E. Snyder, Lansdorf and Sons, Roig and Langsdorf, and Jacob Weber. Cigar manufacturing declined after the 1920s. Snyder Cigars was the best-known maker during the last years. (Perkasie Historical Society.)

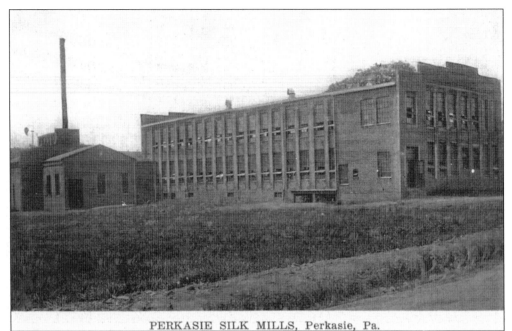

PERKASIE SILK MILLS, Perkasie, Pa.

SILK MILL, NINTH STREET. The Perkasie Silk Mills opened for business in 1912. Draperies were one of its major products. After being vacant for many years, the old mill is now home to First Savings of Perkasie. (Hockman collection.)

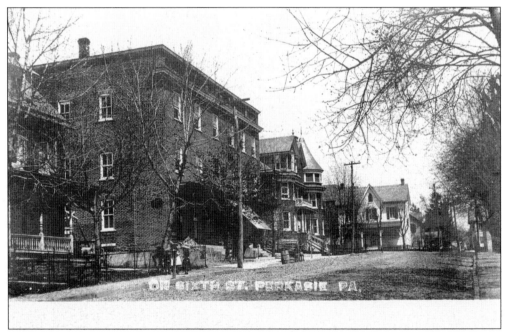

ON SIXTH ST. PERKASIE PA.

BUSINESSES ALONG SOUTH SIXTH STREET. Seen in this *c.* 1910 photograph are business along Sixth Street, between Walnut and Chestnut Streets. From left to right are the Bourse Building, now apartments, and two large homes, now law offices. (Hockman collection.)

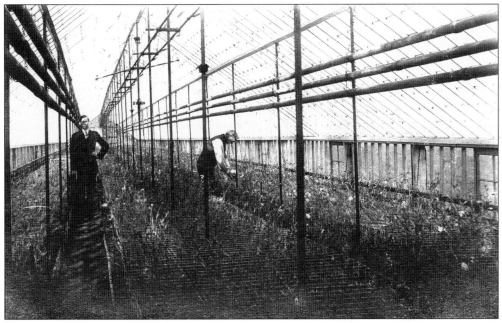

GREENHOUSE AT FIFTH AND CALLOWHILL STREETS. Perkasie had several greenhouses during most of the 20th century. This greenhouse was owned and operated by Benjamin Hedrick, shown at left. Employee Ralph Keller is also shown. This is the approximate location of Clair's Flower Shop today. (Hockman collection.)

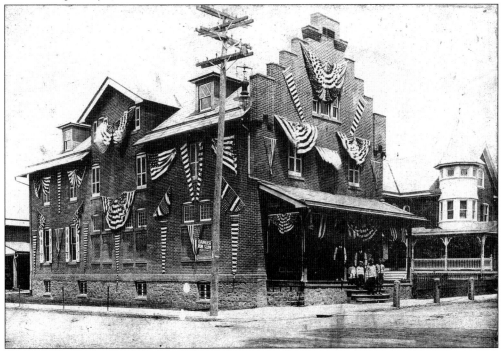

H. D. MOYER STORE, 1903. H. D. Moyer's store was located at Main and Walnut Streets, in South Perkasie. It is now apartments. The decoration might be in honor of Benjamin (South Perkasie) being annexed to Perkasie in 1898. (Perkasie Historical Society.)

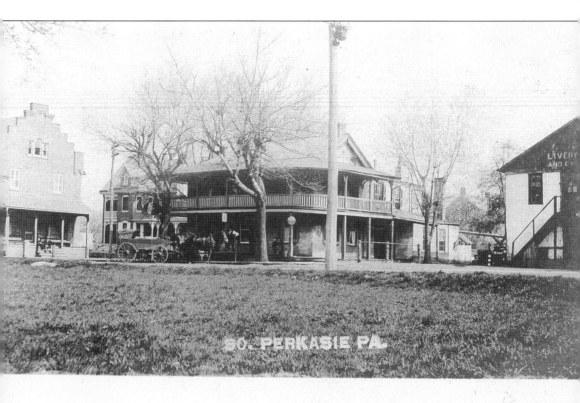

SOUTH PERKASIE'S BUSINESS CENTER. H. D. Moyer's store is seen on the left. Crouthamel's or South Perkasie Hotel, now known as the Perk Restaurant, is on the right. The South Perkasie Hotel has been a commercial center since its construction around 1850. It was built at the crossroads of Hagersville–Sellersville Road (Main Street) and the Hilltown–Quakertown Road (Walnut Street). In its early years, the hotel was a popular stopover for Lehigh Valley merchants and farmers traveling to Philadelphia. Behind the hotel was its cattle market, one of the best known in the country. During its early history, thousands of head of cattle, horses, and pigs were shipped and sold here. The hotel was the birthplace of the "combination sale," today's flea market. The hotel was owned by Russel Kramer and then Mr. Kenderdine, who sold it to George Nacarella in 1975. It was renovated into a restaurant named the Perk and has been operated by George's son Larry since 1985. (Hockman collection.)

Four

CHURCHES AND SCHOOLS

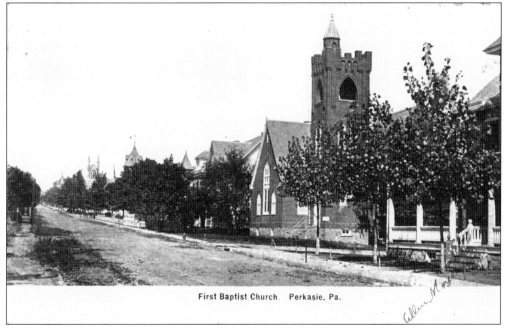

First Baptist Church. Perkasie, Pa.

FIRST BAPTIST CHURCH, C. 1900. Despite its caption, this postcard actually has two churches and Perkasie's public school in it. Located at Fourth and Arch Streets, First Baptist Church has the square Gothic tower. Looking north on Arch Street, the tower of the public school, Fifth and Arch Streets, is above the tree line; in the distance is the steeple of St. Stephen Reform Church.

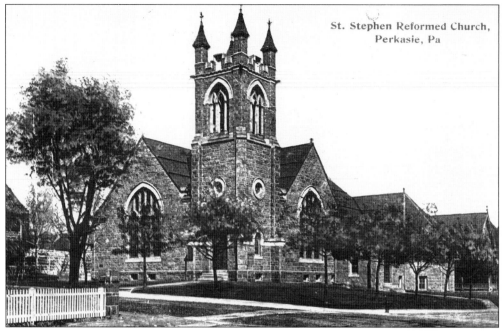

ST. STEPHEN REFORMED CHURCH, 1903. St. Stephen was the first church established in Perkasie. The cornerstone was laid in 1885. Final construction work and dedication occurred in 1904. It is one of the largest churches in the Perkasie area.

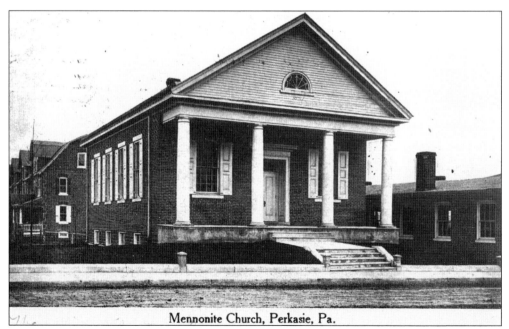

MENNONITE CHURCH, 1911. This meetinghouse at Fourth and Chestnut Streets was a branch of the Blooming Glen Mennonite Church. In 1948, the church was organized as an independent congregation of the Franconia Conference.

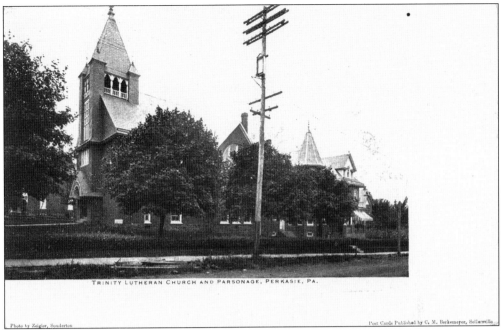

TRINITY LUTHERAN CHURCH AND PARSONAGE, PERKASIE, PA.

Photo by Zeigler, Souderton

Post Cards Published by C. M. Berkemeyer, Sellersville

FIRST TRINITY LUTHERAN CHURCH, 1903. The church was started in 1893. In 1907, this original church was moved about 50 feet away from the corner of Fifth and Market Streets to make room for a large addition.

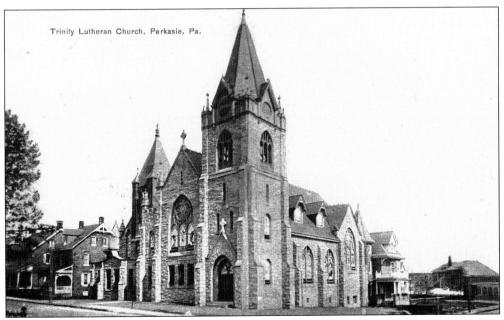

Trinity Lutheran Church, Perkasie, Pa.

ENLARGED TRINITY LUTHERAN CHURCH, C. 1907. As Perkasie grew rapidly, so did its churches. The new Trinity Lutheran Church demonstrates that its congregation was large. The clock tower was completed in 1912 with the financial aid from the community. Therefore, it is called the town clock.

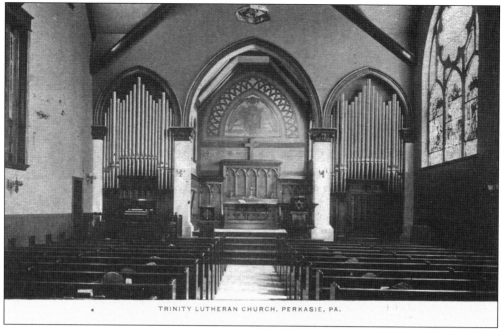

TRINITY'S INTERIOR, 1907 TO EARLY 1960s. This was the church interior from 1907 to 1962. The church was extended in the late 1960s. (Hockman collection.)

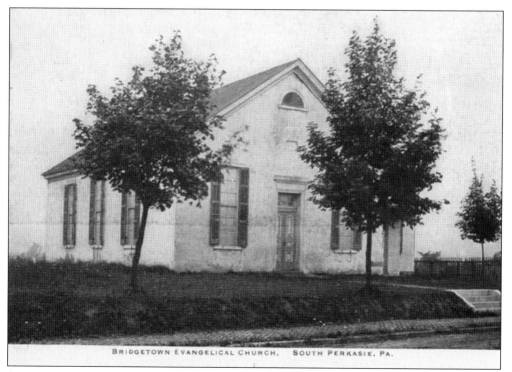

SOUTH PERKASIE'S EVANGELICAL CHURCH, c. 1900. This church was built in 1866 near Main and Market Streets. It was taken down in 1916 in order to expand the cemetery. In 1927, the congregation moved to Fifth and Market Streets in a new church building.

First Evangelical Church, Perkasie, Pa.

FIRST EVANGELICAL CHURCH, MID-1930S. This is the 1927 church for the Evangelical congregation. It was renovated and enlarged in 1956. An interdenominational merger in 1970 created the current United Methodist Church.

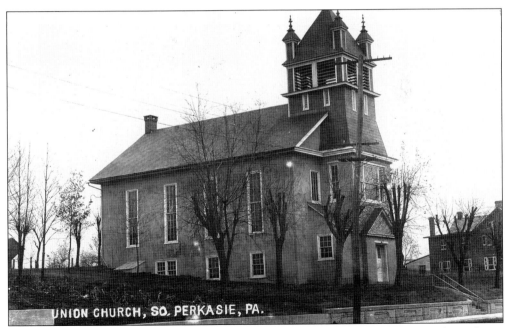

UNION CHURCH, SO. PERKASIE, PA.

UNION CHURCH, SOUTH PERKASIE. Started in 1866 as St. Andrew's Union Church for Lutheran and Reformed congregations, the church property was originally part of the Strassburger estate. This church building was completed in 1870.

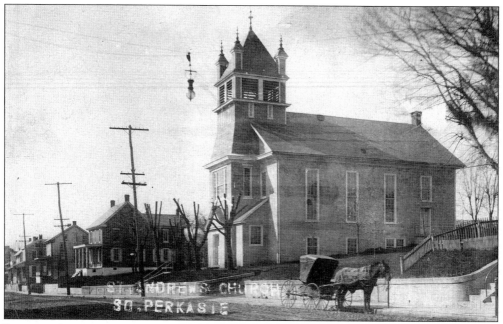

LOOKING NORTH IN SOUTH PERKASIE. Except for the horse and buggy, this 1905 photograph shows a part of Perkasie that has changed little. Notice the early electric light hanging over the street. (Hockman collection.)

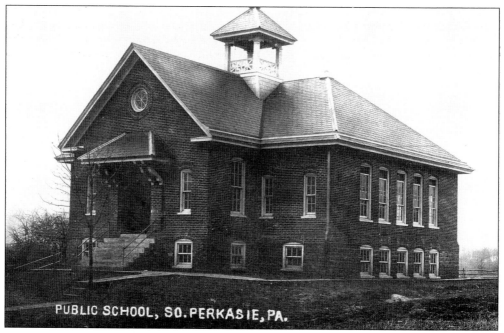

SOUTH PERKASIE'S EARLY SCHOOL. This school was built in 1908, replacing South Perkasie's old schoolhouse. This building was used as an elementary school until 1946, when the students were transferred to the Arch Street School. (Hockman collection.)

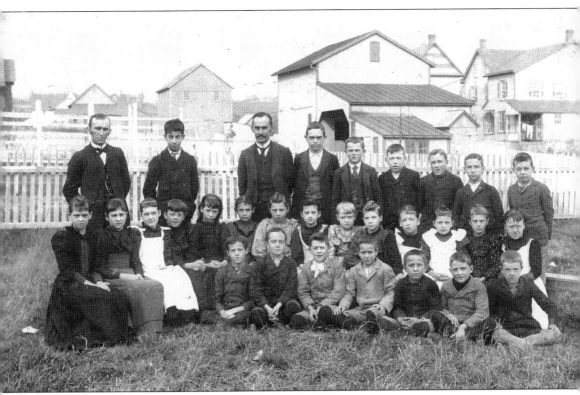

FIRST SCHOOL OF PERKASIE, C. 1880S. Perkasie's first public school built after its incorporation was located at 509 Chestnut Street. The school was acquired from the Rockhill School District. Perkasie expanded the school in 1883. It had 57 pupils the next year. It was replaced by the Arch Street School in 1893. Today it is apartments. The gentleman standing on the left is teacher Milton S. Fulmer. Mustached principal Oliver Fulmer is standing in the center. (Perkasie Historical Society.)

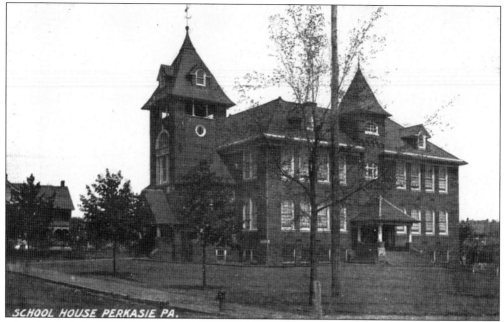

ARCH STREET SCHOOL. In 1892, a new school was built at Fifth and Arch Streets. It was expanded in 1895 and 1901. It served all grades until 1905, when a high school was built on Third Street. The year 1963 was the last year it was used as an elementary school. The Arch Street School was demolished in 1966 to make room for the current Perkasie Fire House.

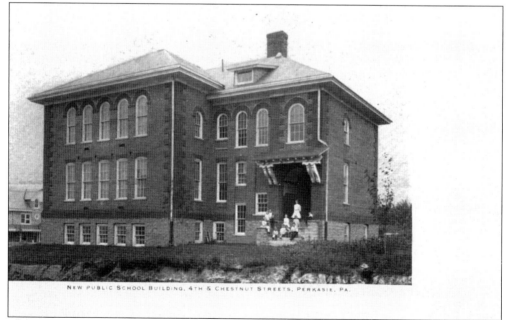

THIRD STREET SCHOOL, C. 1905. Despite the postcard's caption, this school is on Third Street and has had that name for many years. Built as a four-room high school in 1905, it was expanded in 1914 with five rooms, an auditorium, and a gymnasium. When Sell–Perk High School opened in 1930, it became a junior high and was later an elementary school until 1977. Today the former school is an apartment complex with the appropriate name: Chalkboard Apartments.

70

SIXTH-GRADE CLASS, *C.* **1905.** This class photograph was taken outside the Arch Street School. (Hockman collection.)

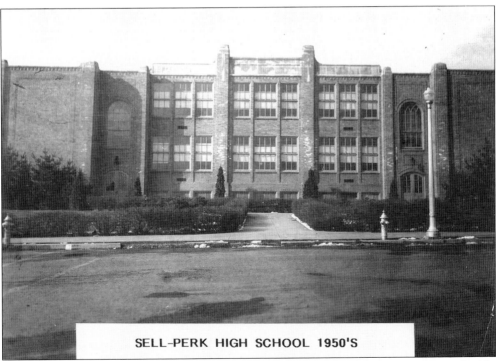

SELL–PERK HIGH SCHOOL 1950'S

SELL-PERK HIGH SCHOOL. The boroughs of Sellersville and Perkasie came together to build a joint high school that opened in 1930. It continued to be the high school until Pennridge High School opened in 1954, and then it became a junior high school. After major expansion and renovations it is Pennridge South Middle School. (Perkasie Historical Society.)

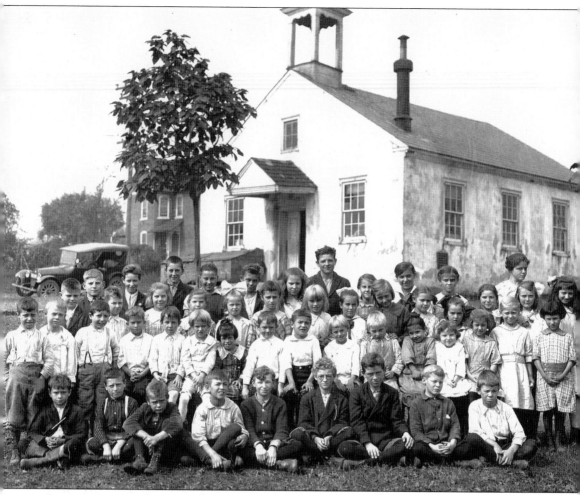

LESSIG'S SCHOOL, C. 1921. This one-room schoolhouse is located on Park Avenue, just below Ridge Road. Built in the late 1800s, this schoolhouse was first part of the Rockhill Township Schools. This area along Ridge Road was annexed to Perkasie in 1930.

Five

TOWN LIFE

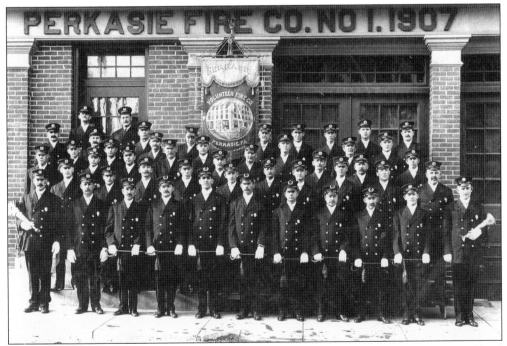

PERKASIE FIRE COMPANY, 1912. On a snowy January 16, 1912, members posed for this official photograph of the Perkasie Fire Company. Perkasie commercial photographer Charles M. Wimmer took the photograph under apparently difficult conditions. The fire company used this building as its firehouse from 1907 until 1969, when a new firehouse was built at Fifth and Arch Streets. (Perkasie Historical Society.)

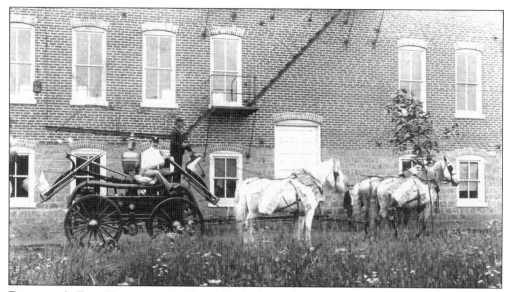

BENJAMIN'S FIRE ENGINE, 1908. South Perkasie was known as Benjamin when it had its own post office in the 1890s up to 1910. It never became a self-ruling town, a borough. However, the men of Benjamin organized their own fire brigade, probably because the Perkasie firehouse was more than a mile away and only the Walnut Street Bridge gave access for fire equipment to reach South Perkasie. (Hockman collection.)

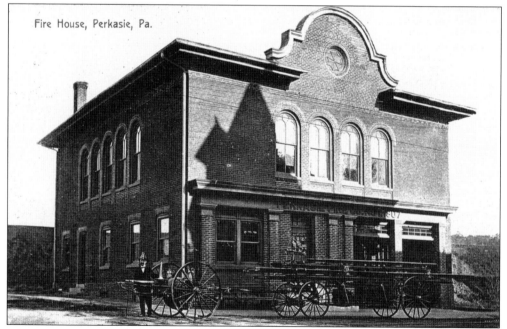

Fire House, Perkasie, Pa.

PERKASIE FIREHOUSE, C. 1910. The Perkasie Fire Company was established in 1890, shortly after a major fire threatened the town and the neighboring Sellersville Fire Company had to save Perkasie. For its first 17 years, the fire company was housed in a local livery stable, then at Cressman's Building near Seven and Arch Streets. This firehouse was built in 1907. As seen in this photograph, horsepower was still used by rural fire companies in 1910. Today this building is a machine shop. (Hockman collection.)

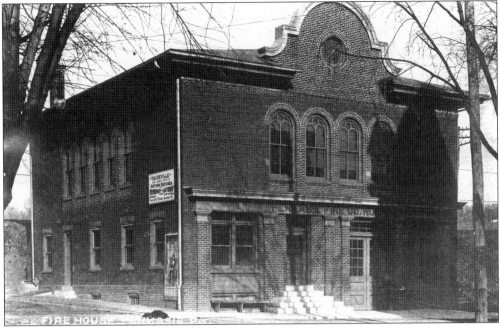

FIREHOUSE AS THEATER, C. 1910. On the second floor of the firehouse was a meeting room that also was used for vaudeville shows and to show motion pictures. The fire company raised much of its funds by charging admissions to these entertainment events. The two posters on the side wall advertise a vaudeville show and motion picture every Wednesday and Saturday. (Perkasie Historical Society.)

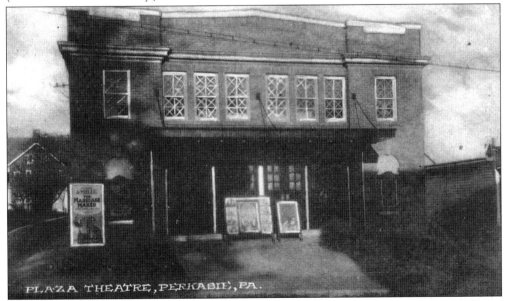

PLAZA THEATRE, 1920s. The Perkasie Fire Company built this theater for motion pictures in 1922. It is located on Market Street, between Sixth and Seventh Streets. The theater was profitable for the fire company until the Depression. During the 1930s, it was sold to a businessman who ran the movie theater until its interior was destroyed in 1950. Today the building is a restaurant. (Hockman collection.)

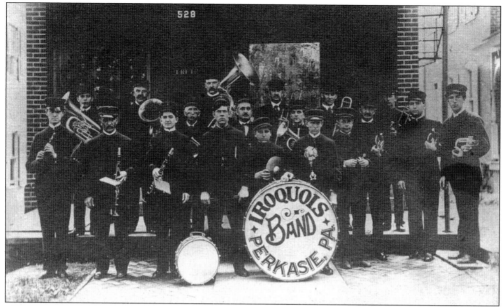

IROQUOIS BAND, C. 1910. This community band doubled as a social group for young men. They performed at local events and marched in parades. They met at the Cressman Building on Seventh Street near Arch Street. When the Cressman Building was destroyed by fire in 1922, the Iroquois Band lost all its instruments and dissolved shortly afterward. (Perkasie Historical Society.)

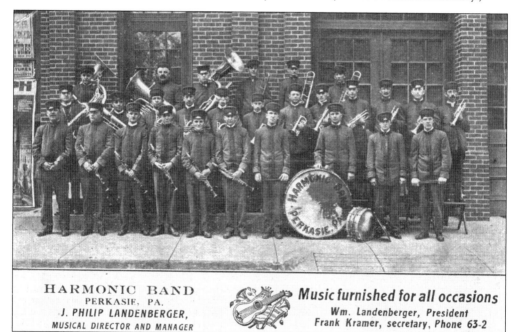

HARMONIC BAND, C. 1910. The Landenberger family played a prominent role in the social and cultural life of young Perkasie. Philip Landenberger was the director of this community band. William Landenberger was a noted painter. Together the brothers performed music for radio concerts broadcasted from Philadelphia. They also painted murals for public buildings in the surrounding communities.

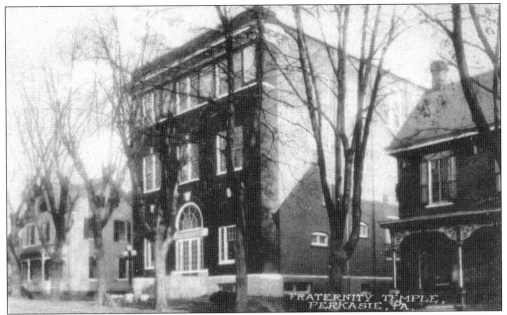

FRATERNITY TEMPLE, LATE 1920s. When the Cressman Building burned to the ground in the great fire of 1922, most social groups in Perkasie lost their meeting place and much of their artifacts. This new fraternity hall was built in the mid-1920s to provide a home for Perkasie's social organizations. Each fraternity and sorority group got its own room. The fraternity temple was located on Sixth Street between Walnut and Chestnut Streets. Today it is a senior apartment building.

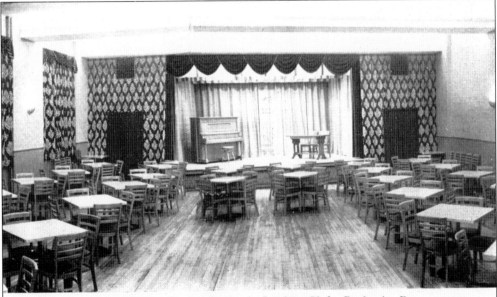

Main Dining Room, Perkasie Legion Club, Perkasie, Pa.

PERKASIE LEGION HALL, C. 1940s. The Perkasie Legion Club had the largest space in the fraternity temple. It had this dining room and a bar. This space was a very popular social gathering place. When the Legion left, this room became the home of the Pierce Free Library until its new home was built in Menlo Park.

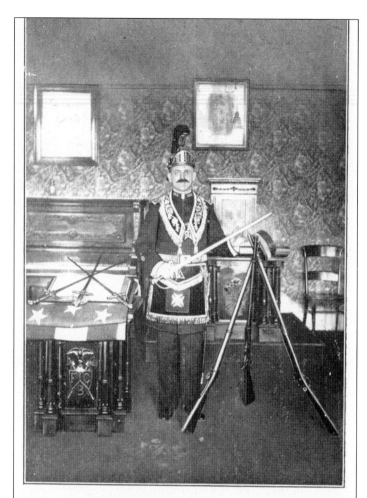

MEMBER OF MANY FRATERNITIES. Cornelius Hendricks is a prime example of how social and welfare organizations played a major role in people's lives before television, radio, and modern communications. Hendricks was a member of four groups. Perkasie had eight male social organizations and 10 women's groups in 1920.

PAST OFFICER CORNELIUS F. HENDRICKS
TOTALLY BLIND, EMBLEMATICALLY REPRESENTING THE FOLLOWING ORDERS:
PERKASIE LODGE, NO. 671, I. O. O. F.
MONT ALTO LODGE. NO. 246, K. OF P.
AMALFI COMMANDERY, NO. 392, A. & I. O. K. OF M.
COL. EDWIN SCHALL POST, CAMP NO. 92, S. OF V.

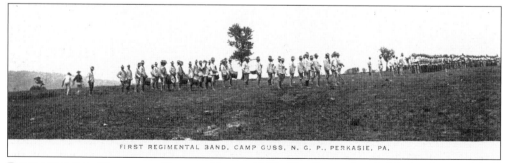

FIRST REGIMENTAL BAND, CAMP GUSS, N. G. P., PERKASIE, PA.

PENNSYLVANIA NATIONAL GUARD CAMP, 1907. The Pennsylvania National Guard held biennial training camp on Tunnel Farm from 1895 to 1910. Each one-week encampment was given a name. Camp Guss was held July 6–13, 1907. Soldiers from across Pennsylvania came mainly by trolley, sometimes starting their journey by train.

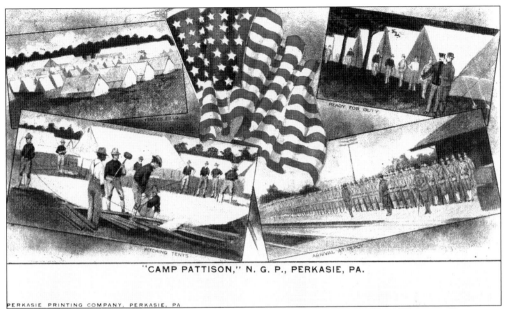

"CAMP PATTISON," N. G. P., PERKASIE, PA.

PERKASIE PRINTING COMPANY, PERKASIE, PA

CAMP PATTISON, 1905. The Pennsylvania National Guard selected Perkasie's Tunnel Farm for its large training camp because the 225-acre location was ideal for tents housing 3,500 soldiers in battalion lines. There was also a large area for a parade ground. Today the Pennridge Airport takes up much of Tunnel Farm.

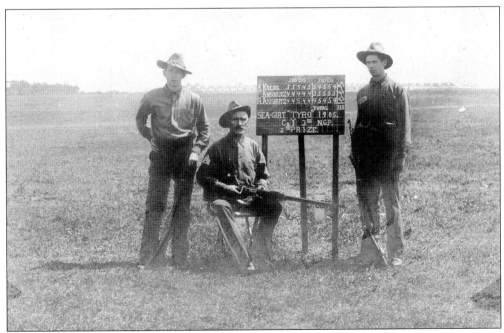

TARGET COMPETITION. The National Guard soldiers practiced military tactics and drills and marched as regiments. They also had time for some recreation such as this rifle target competition. There are stories that on occasions the soldiers caused problems in town, such as public drunkenness. One postcard message states, "have you heard about the soldier who broke his neck." However, they also brought $20,000 to local businesses. (Perkasie Historical Society.)

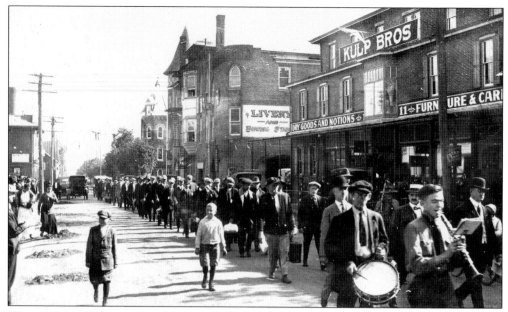

WORLD WAR I DRAFTEES, MARCH 1917. Ralph Moyer, father of James I. Moyer, leads the parade by playing his clarinet. Perkasie was home to the Draft Bureau for the upper region of Bucks County for World War I. Perkasie's excellent transportation network made it conducive for moving large groups, such as soldiers. This parade marches along Seventh Street from Arch Street and then two blocks west to the train station. Notice the future soldiers carrying suitcases or sacks.

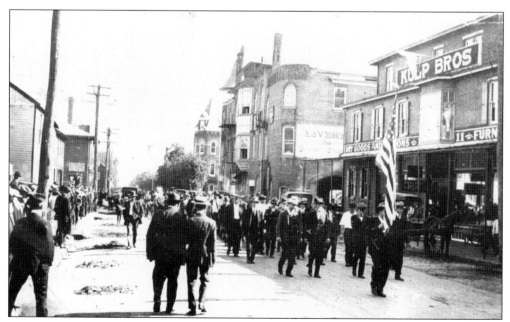

PARADE HONORING DRAFTEES, 1917. Community leaders march at the head of the parade to honor their young men going to war, most likely overseas. A large crowd of citizens and relatives watch and cheer. Notice that both motor power and horsepower share the streets of Perkasie.

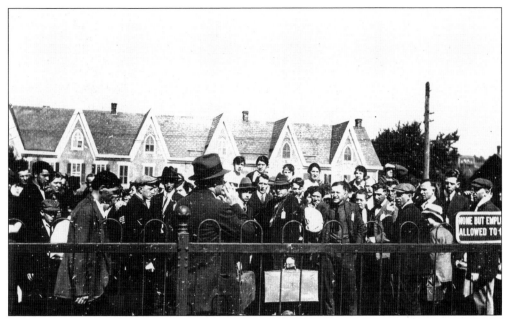

DRAFTEES AT PERKASIE STATION. Draftees are getting final directions from a member of a local draft board just before boarding a train that will transport them to boot camp. Prominent men of the community served on the draft board. The Upper Bucks Draft Board was headquartered in Perkasie. Row houses on Eighth Street are seen in the background.

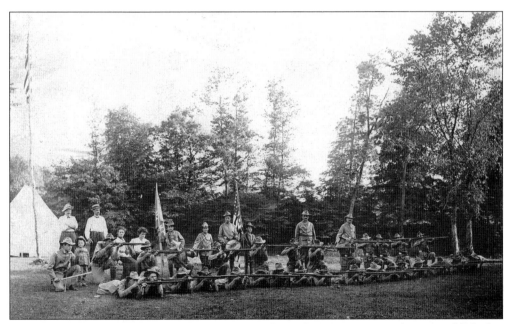

PERKASIE'S BOYS BRIGADE, C. 1908. In 1908, the Perkasie's Boys Brigade was established as a nondenominational organization with the purpose of Bible training, literary, missionary, and patriotic studies. Before being of military age, many boys joined clubs that gave them a sense of what it meant to be a soldier and a good citizen. Whether they actually used the rifles or used them for marching practice is unclear. (Perkasie Historical Society.)

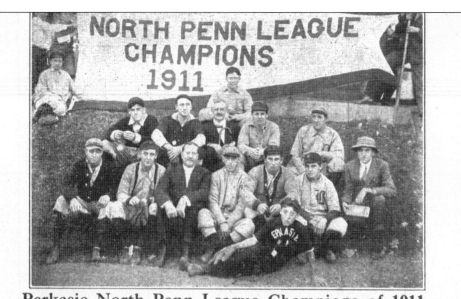

Perkasie North Penn League Champions of 1911.

Top row, reading left to right—Eldridge, p.; Perkins, rf.; C. F. Hendricks, President; Reynolds, Captain and 1b.; Robinson, lf.; Ochs, c. Lower row—Biddle, cf.; Fenton, 2b.; A. M. Jenkins, President of North Penn League; Cavanaugh, 3b.; Chilcotte, ss.; Sterner, Mascot; Wisler, sub.; Clarence Hendricks, Scorer

PERKASIE BASEBALL CHAMPIONS. Baseball was and still is a major part of Perkasie's youth recreation and community pride. Pictured here are two early championship teams: 1911 (above) and 1913 (below). The North Penn League is named after the railroad that linked communities between Philadelphia and Bethlehem. Before motor vehicles were common, teams often used the trains or trolleys to get to away games. The location of the ball field shown in the 1913 image is believed to be near Sixth and Elm Streets, but no clear evidence survives today. (Perkasie Historical Society.)

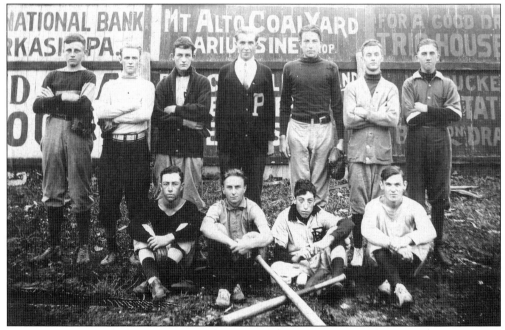

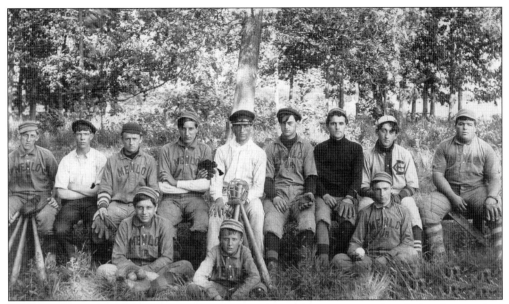

MENLO PARK'S BASEBALL TEAM, C. 1900. Menlo Park's team was semiprofessional, comprised of local talent who played visiting teams on Menlo's baseball field. Baseball was so big in Perkasie that Connie Mack's Philadelphia Athletics traveled to Perkasie on October 7, 1909, to play the Perkasie Athletic Association. Mack promised to play his regulars. Four hall of famers were on the 1909 Athletics: Eddie Collins, Eddie Plank, Frank Baker, and Connie Mack. Local factories closed so their workers could watch the game. Mack probably was willing to bring his team to Perkasie because his new ballpark, Shibe Park, in North Philadelphia was along the trolley line that came to Perkasie and Upper Bucks County. (Perkasie Historical Society.)

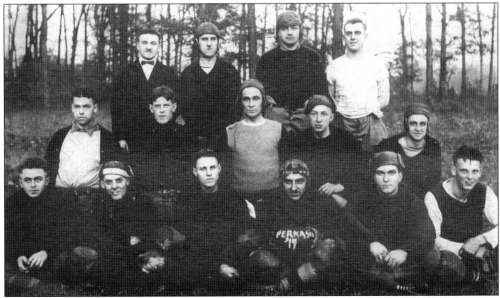

LONG FOOTBALL TRADITION, 1919. Football was also a major part of sports recreation in the Perkasie area. Here the 1919 Perkasie team shows how tough early football was by the lack of protective equipment. Football was strictly a running game with many broken noses and limbs. Notice the leather helmets with no face guards. (Perkasie Historical Society.)

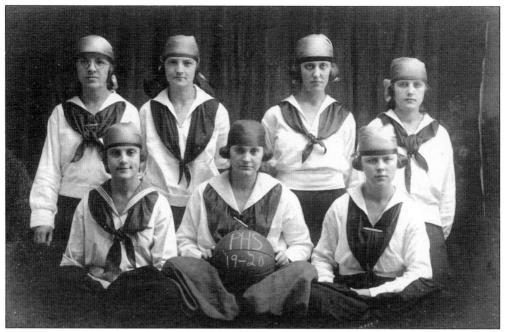

GIRLS' BASKETBALL, 1919–1920. Girls' basketball was still in its infancy in 1920 when these six girls played for Perkasie High School. Their uniforms represent the time period's code of modesty and how girls played basketball. (Perkasie Historical Society.)

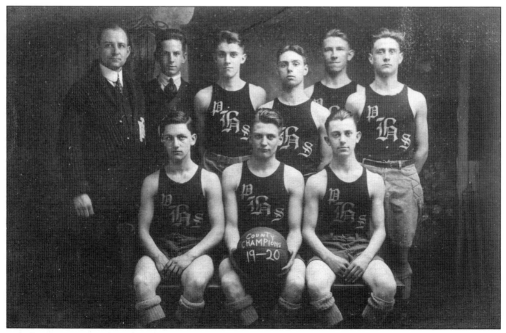

BASKETBALL TEAM, 1919–1920. Clayton Pritchard, front center, was captain of the Perkasie High School basketball team in 1919–1920. After high school, Pritchard was a home builder in Perkasie. (Perkasie Historical Society.)

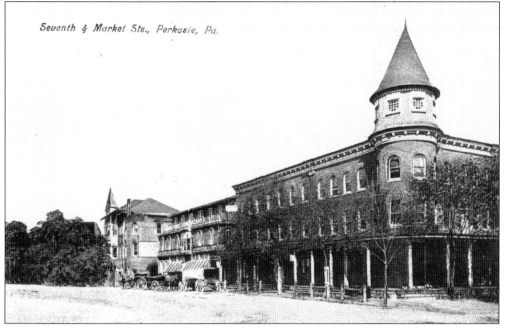

Seventh & Market Sts., Perkasie, Pa.

SEVENTH AND MARKET STREETS, 1910. Pictured from left to right are the Cressman Fraternity Building; a livery stable; the Kulp Brothers Grand Bazaar, a small department store; and the American House hotel and bar. All of these buildings were destroyed by fires, either in 1922 or 1988.

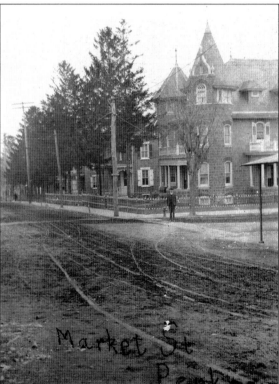

PERKASIE MANSION, 1906. This homemade photograph postcard gives a rare view of the mansion at Seventh and Market Streets. It was made of black granite quarried near Rockhill, a few miles north of Perkasie. There are several mansions similar to this one still existing in Perkasie. In 1906, the streets of Perkasie were of compacted dirt with brick walkways for crossing the street. The mansion was demolished in 1964 as part of Perkasie's urban renewal. (Hockman collection.)

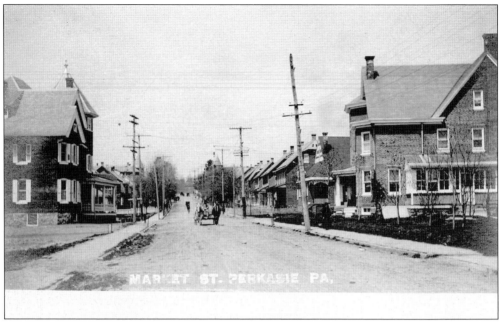

MARKET STREET, *C.* **1905.** This view is from Fourth and Market Streets looking north toward the railroad tracks. (Hockman collection.)

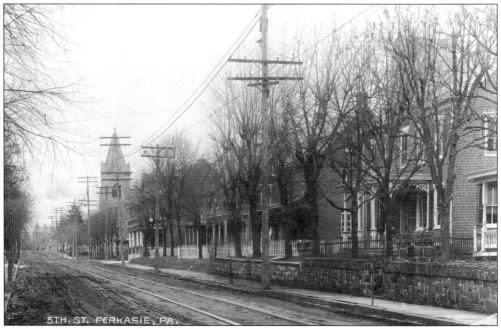

FIFTH STREET, *C.* **1905.** Taken at Walnut and Fifth Streets, this scene shows the trolley tracks going down Fifth Street toward Market Street. Within a few years, the trolley tracks were moved to go up Walnut Street to its new station. The Trinity Lutheran Church tower is seen with the town clock, which still operates today. (Hockman collection.)

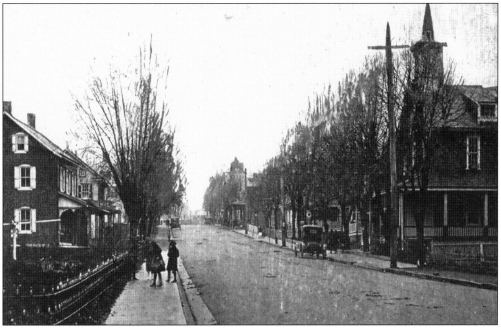

CHESTNUT STREET, LOOKING NORTH, C. 1925. In 1894, Perkasie Borough adopted the Philadelphia plan for naming streets, tree names west of Market and to the east: Arch, Race, Vine, and Callowhill. This *c.* 1920 view looks north from Fifth Street toward the train tracks. The building on the right was the first school in Perkasie, already converted to housing.

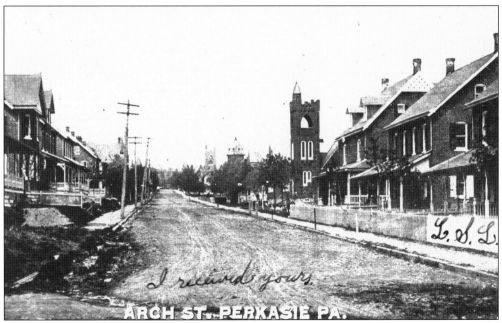

ARCH STREET, LOOKING NORTH, C. 1905. When Perkasie rapidly grew in the 1890s, Arch Street quickly was built up with houses, two churches, and the public school. These buildings are identified by their towers; along the right side is the First Baptist Church, the public school, and St. Stephen Reform Church in the distance.

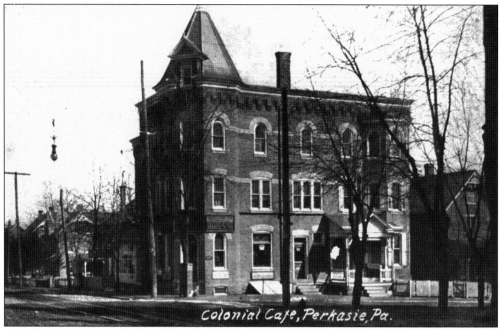

Colonial Cafe, Perkasie, Pa.

SEVENTH AND ARCH STREETS, C. 1915. It was common for large buildings to have multiple uses. While the caption refers only to an eatery, the Colonial Café also housed the Roigs Cigar Factory, a store, and apartments. The Colonial Café is now the Alden Apartments. The small building to the right is now the Arch Street Deli. (Hockman collection.)

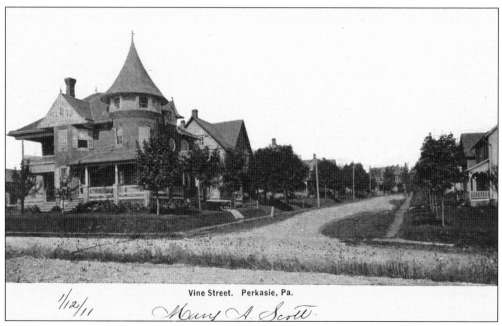

Vine Street. Perkasie, Pa.

VINE STREET, LOOKING NORTH, 1910. Perkasie grew during the American Victorian architecture period; therefore it had many large Victorian homes. Some have been lost to urban redevelopment. But many still exist, such as this beautiful Victorian at Fifth and Vine Streets. Many were built using locally quarried granite, usually a dark grey.

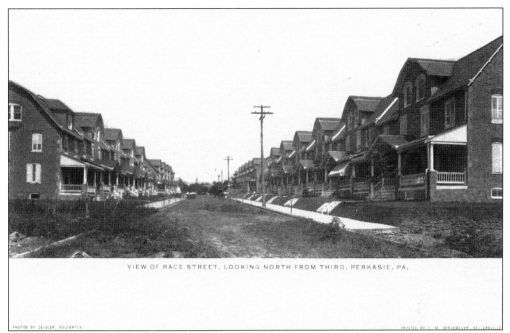

VIEW OF RACE STREET, LOOKING NORTH FROM THIRD, PERKASIE, PA.

RACE STREET, LOOKING NORTH, 1905. Much of Perkasie's rapid population growth was enabled by small row house or block house developments. Real estate developers and/or housing contractors would build houses along a street block, as seen in this postcard. This is the block on Race Street between Third and Fourth Streets.

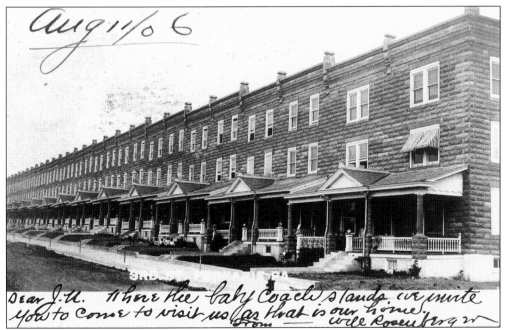

Aug 11/0 6

Dear J.U. Where the baby coach stands, we invite you to come to visit us as that is our home. From ____ Will Rosenberg w

PERKASIE'S LONG ROW OF HOUSES. On Third Street is the longest set of row houses in Perkasie, 28 homes on one side of Third Street. Despite being narrow, these homes could accommodate large families because of being three levels high and extending deep on the lot. Perkasie's rapid manufacturing growth attracted workers.

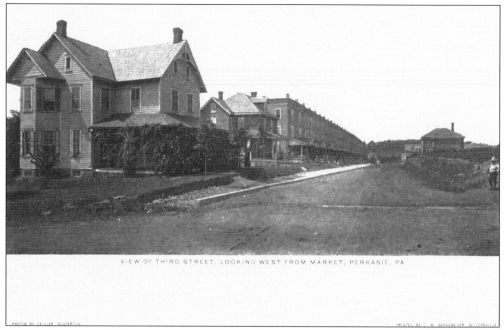

VIEW OF THIRD STREET, LOOKING WEST FROM MARKET, PERKASIE, PA

THIRD STREET, 1905. The entire block of Third Street is seen with the long line of row houses and the recently built public school across the street. Neighborhood children used the school playground.

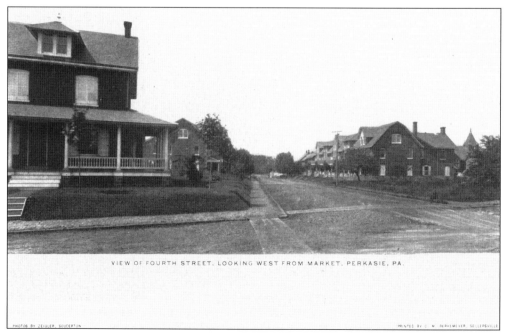

VIEW OF FOURTH STREET, LOOKING WEST FROM MARKET, PERKASIE, PA.

FOURTH STREET, LOOKING WEST, 1905. This postcard shows the substantial size of the row houses built in many parts of Perkasie. There are 13 blocks of row homes in Perkasie. Notice the paved walkways for crossing the dirt streets at the intersection.

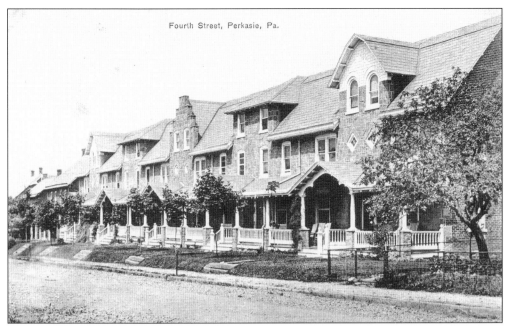

CLOSE-UP OF FOURTH STREET HOMES. This postcard shows the typical row house development built in Perkasie more than 100 years ago. Brick was mainly used to build these and other Perkasie houses. But, like these homes, local granite was used on the front facade. (Hockman collection.)

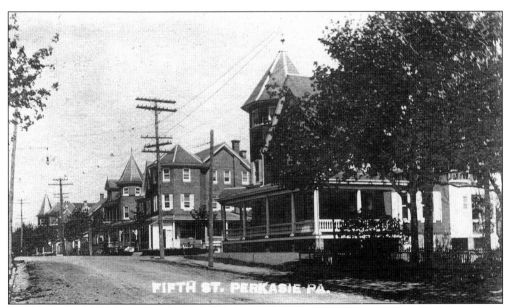

FIFTH STREET, 1910. Fifth Street has been a major transportation street even before Perkasie existed. Fifth Street was originally part of the Hagersville–Sellersville Road. It was used by farmers and villagers from Bedminster and Hilltown Townships to connect with Bethlehem Pike or to go to the railroad station at Sellersville. When Perkasie grew rapidly in the late 1800s, many homes, businesses, and churches were built along this street.

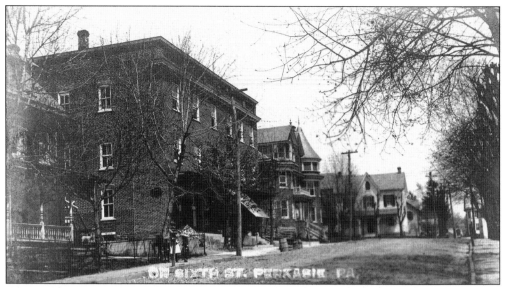

SIXTH STREET. This postcard shows Sixth Street between Walnut and Chestnut Streets around 1910. The large building left of center was called the Bourse, a popular meeting place for local businessmen. To the right are two large houses that are now used as law offices.

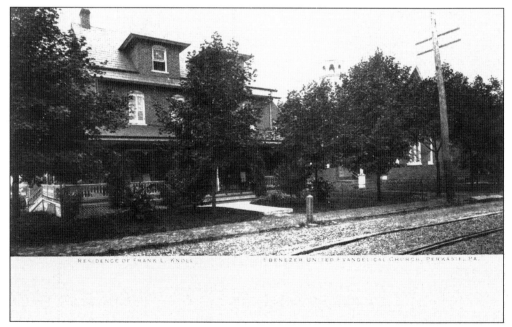

MARKET STREET, NEAR FIFTH STREET, 1905. Frank L. Knoll was an undertaker in town; his home is on the left. The steepled building is the Ebenezer United Evangelical Church, which merged with another Evangelical congregation in 1922. This church was demolished for a new Evangelical church. Today the United Methodist Church is located on this corner.

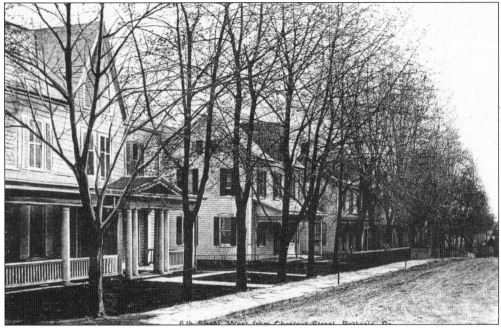

SIXTH STREET, 1908. This 1908 view shows the south side of Sixth Street between Chestnut and Walnut Streets. Today a law firm is located in the building at left. Houses in the middle of the block were removed in the 1920s to make room for the fraternity hall, now senior citizen housing.

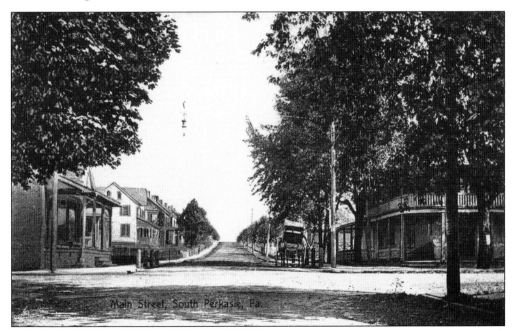

SOUTH PERKASIE MAIN INTERSECTION, 1910. This view was taken looking east, just 100 yards in front of the old covered bridge, now in Menlo Park. At Main and Walnut Streets most of the commercial activity of South Perkasie occurred since the 1850s. Despite never becoming its own town, South Perkasie was a major economic center for Upper Bucks County.

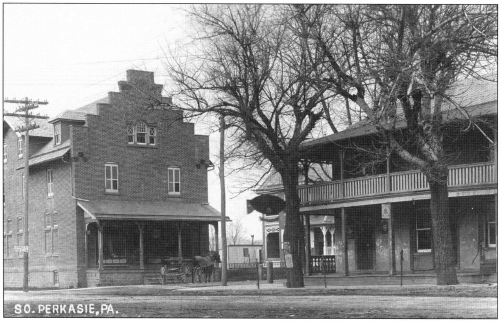

SOUTH PERKASIE'S HUB, *C.* 1905. Moyer's store is on the left, now an apartment building. The Bridgetown Hotel on the right is the current Perk Restaurant. During the late 1800s, this hotel provided rooms and food to travelers. Many animal auctions were held in its livery stable. Today both buildings are examples of successful use of historic structures. (Hockman collection.)

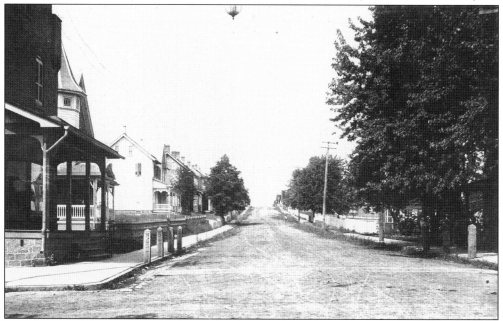

MAIN STREET, SOUTH PERKASIE. This street was the main street of South Perkasie and not for boomtown Perkasie. Looking east, the hitching posts and telephone poles help date this photographic postcard as being taken around 1905. Along this street, but not seen, would be the South Perkasie public school. Continuing on this street would lead to Branch Road and the Steeley Covered Bridge, removed in the 1930s. (Hockman collection.)

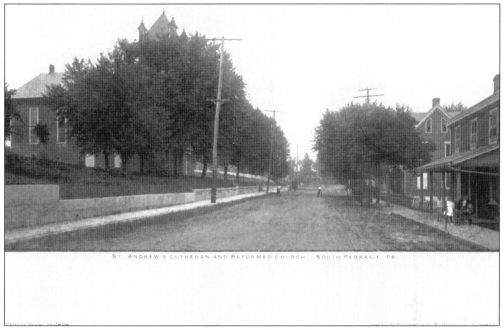

ST. ANDREW'S LUTHERAN AND REFORMED CHURCH, SOUTH PERKASIE, PA.

WALNUT STREET, FACING SOUTH, 1905. This is the south section of South Perkasie. St. Andrew's Reformed Church is on the left. Across the street, but out of view, is the gristmill (see front cover). In the distance at the street's end is the Strassburger Homestead.

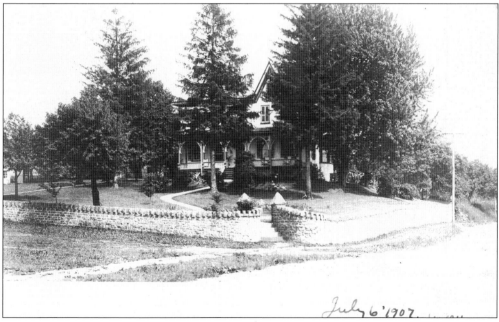

July 6 '1907.

STRASSBURGER HOMESTEAD, 1907. This mansion is the last building in Perkasie as one travels south on Walnut Street into Hilltown Township. The Strassburger family owned various properties in the area and built this homestead when they operated the South Perkasie mill during the late 1800s. (Hockman collection.)

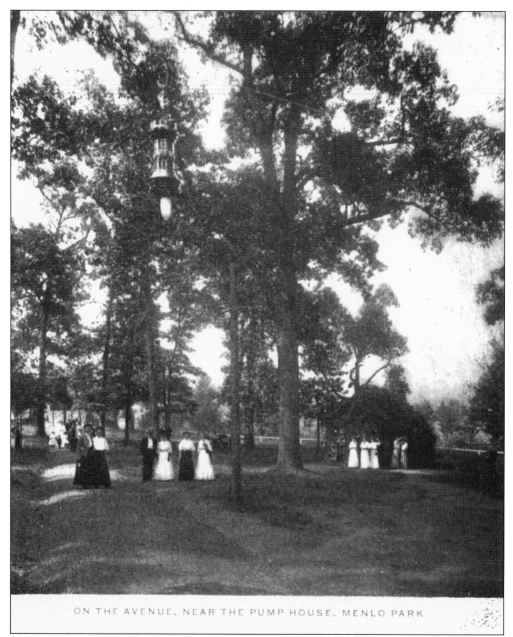

ON THE AVENUE, NEAR THE PUMP HOUSE, MENLO PARK

PERKASIE'S BEAUTIFUL REFUGE. This idyllic postcard was produced around 1903 at the height of Menlo Park as a major amusement park for southeastern Pennsylvania. However, Perkasie's Menlo Park was not just for visitors. Residents of Perkasie, then and now, use the park for recreation and quiet relaxation. In the past it was an amusement park with many thrill rides, boating, and picnicking. Today the park is owned and maintained by Perkasie Borough with facilities for its citizens such as a new swimming park, baseball fields, a skateboard area, walking/biking paths, picnic tables, and so on. The Menlo's carousel is owned and operated by the Perkasie Historical Society. Rides are given on scheduled days during the year. The place where this postcard shows now has two pavilions and part of the swimming pool parking lot. Ironically, the photographer stood in front of the carousel. There are no known exterior photographs of the carousel.

Six

NEARBY COMMUNITIES

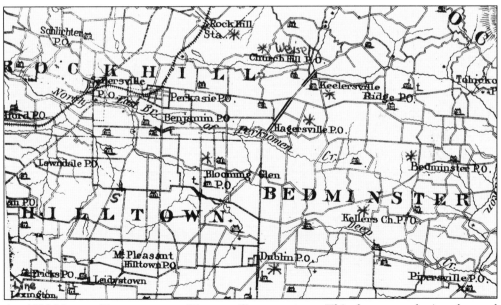

AN 1891 MAP OF PERKASIE AND NEARBY COMMUNITIES. This chapter emphasizes the rural communities that helped create Perkasie with their commerce and social ties: the boroughs of Silverdale and Dublin; the villages of Blooming Glen, Hagersville, and Kellers Church; and the townships of East Rockhill and Bedminster (asterisk on map above). Long ago farmers and villagers brought their agricultural and factory products to Perkasie for transportation to cities like Philadelphia and Allentown. Rural families also came to Perkasie to buy household items and for entertainment at Menlo Park or to watch a moving picture. Their strong connection with Perkasie is represented by having a photograph of the Perkasie Train Station on the back of early postcards with views of these rural communities. (Atlas of Bucks County, Pennsylvania.)

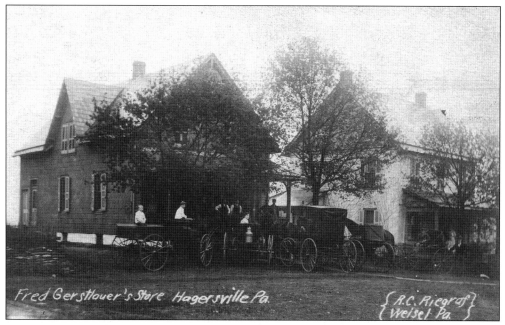

Fred Gerstlouer's Store Hagersville Pa.

{A.C. Riegro}
Weisel Pa.

HAGERSVILLE GENERAL STORE, C. 1900. The "father" of Perkasie, Samuel Hager, came from Hagersville, a small village that straddled the boundary of Rockhill and Bedminster Townships. The Bethlehem Road, one of the earliest in the mid-Atlantic region, went through Hagersville. Before railroads, nearly all traffic between Bethlehem and Philadelphia would have passed this store. A major farm road also went from Hagersville to Sellersville. (Hockman collection.)

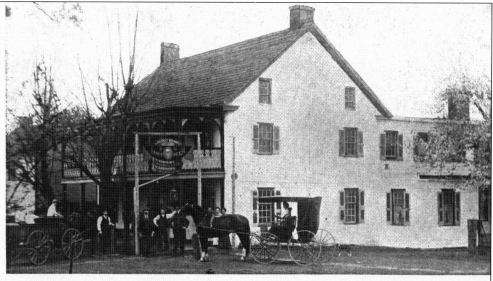

413. BUCKS COUNTY (P.A.) VIEWS.
Arnold Bros., Printers, Rushland, Pa.

HAGERSVILLE HOTEL
Edw. K. Harrison, Prop'r.

HAGERSVILLE HOTEL. Numerous small hotels lined Bethlehem Road. The heavy horse-powered traffic also supported businesses such as wheelwrights, saddle-makers, blacksmiths, feed stores, and tanneries. When Lake Nockamixon was created in the 1960s, this part of the Bethlehem Road became a dead end, greatly reducing traffic. This former hotel is now a private residence. (Hockman collection.)

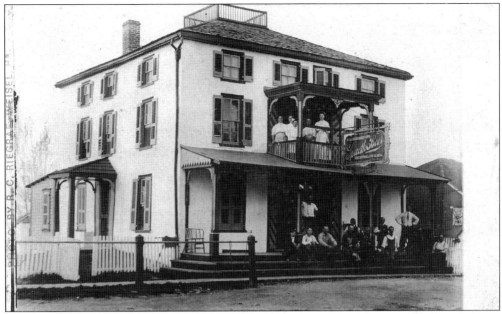

EAST ROCKHILL CENTRAL HOTEL, C. 1900. This hotel is located along the Ridge Road just north of Perkasie. Today it is Emil's Restaurant. Notice the crow's nest on the roof. It was not to spot ships; rather it was used to get a 20-mile panoramic view from the ridge. The Ridge Road has been a route between small towns of Upper Bucks and Montgomery Counties since early Colonial times. (Hockman collection.)

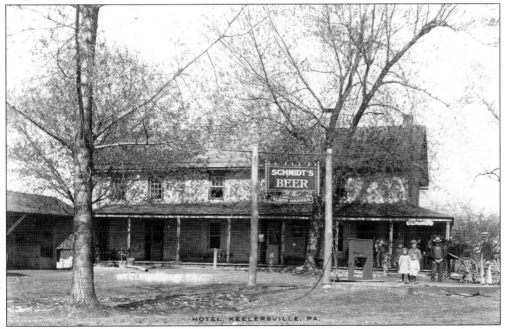

HOTEL, KEELERSVILLE, C. 1900. Keelersville was a town just north of Hagersville along the old Bethlehem Road. Like Hagersville, it thrived with many small businesses based on horse-powered traffic. When traffic was diverted away for Bethlehem Road in the 20th century, its businesses, like this hotel, died. (Hockman collection.)

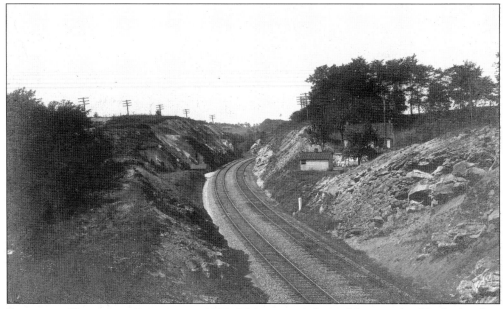

ROCKHILL RAILROAD CUTOUT, C. 1900. This cutout is located just north of Perkasie, close to the Perkasie Tunnel. This cutout took significant engineering in order to permit trains a gradual climb and turn at the same time. Some quarries were started when usable rock was found. Notice the small building near the curve; it was a water stop for steam locomotives. (Hockman collection.)

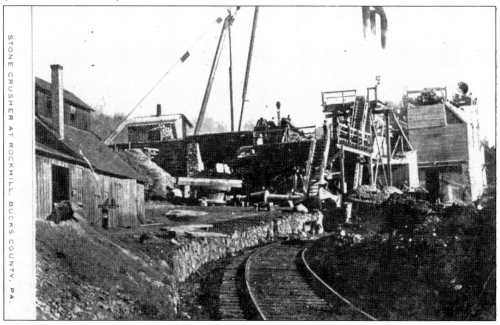

STONE CRUSHER, ROCKHILL. This early rare postcard shows a rock quarry. It was started by the railroad company to create crushed stone for railroad track beds. Later, quarries became a major economic activity of Rockhill Township, especially where the land is poor for farming. Quarrying for building stone also happened. Many of Perkasie's early houses are made of stone quarried locally and delivered by freight train. (Hockman collection.)

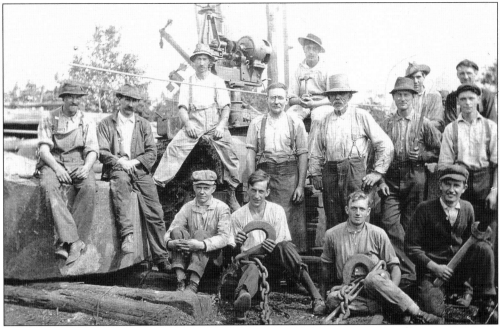

ROCKHILL STEEL BLASTING WORKS. These hardy men worked in the Rockhill Quarry, which used the railroad to get granite to market. Several homes in Perkasie and local communities were built using the dark grey granite. Being a quarry worker was dangerous work. The two men in the upper right (third row), Lewis Kock Jr. and Irwin Moyer, were killed by a premature dynamite explosion. (Perkasie Historical Society.)

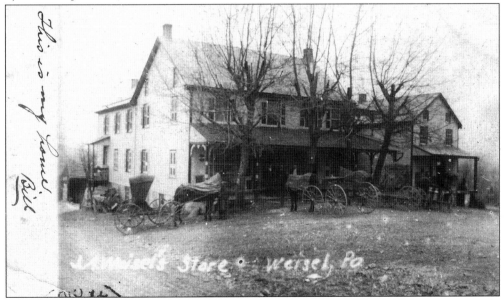

WEISEL'S STORE, WEISEL. Weisel is just north of Hagersville and Keelersville along the old Bethlehem Road. This general store is located just before the road goes down into a valley. Three Mile Run Stream was dammed during the 1960s, making this location the end of Bethlehem Road. This building was converted into a restaurant and now is a wedding reception hall. (Hockman collection.)

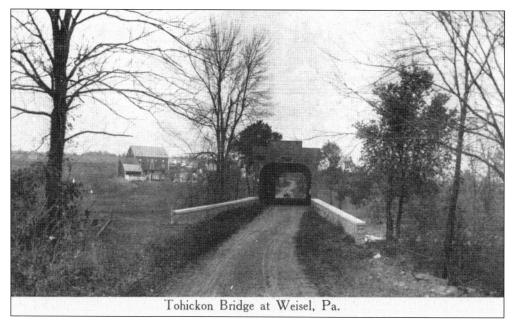

Tohickon Bridge at Weisel, Pa.

TOHICKON BRIDGE AT WEISEL. This bridge was just north of the Weisel store (page 101) and it crossed Three Mile Run Stream. This bridge and its surrounding area have been under Lake Nockamixon since the late 1960s, when the reservoir was created. (Hockman collection.)

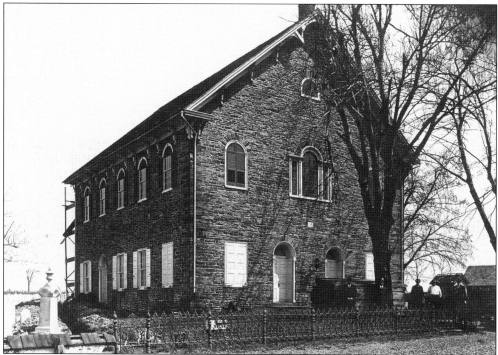

TOHICKON UNION CHURCH, C. 1910. This is one of the earliest stone churches in Bucks County, located along old Bethlehem Road in Weisel. For its early years, the church was shared by two congregations: Lutheran and Reform. There was a front door for each congregation. Its cemetery has many early, finely carved tombstones. (Perkasie Historical Society.)

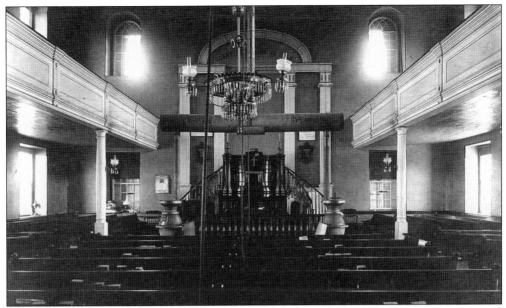

Tohickon Church Interior, *c*. 1910. This is a scarce view of an early church interior. Notice the two potbelly stoves in front of the pulpit along with its elevated heating pipe. This must have made it difficult for some worshipers to see the minister. Also notice the early lighting fixtures. (Perkasie Historical Society.)

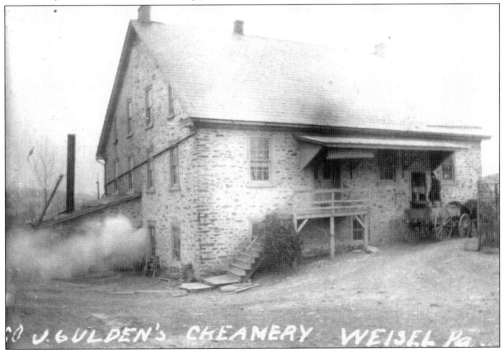

J. Gulden's Creamery, Weisel, 1908. Creameries were an essential part of dairy farming. Milk was prepared for market by removing the cream to make butter and cottage cheese. Creameries were along streams or over cold springs so that the cool water could be used to keep the milk fresh. (Hockman collection.)

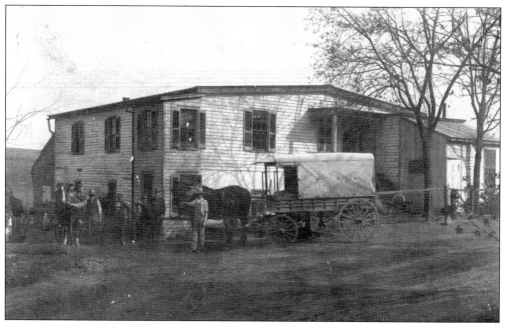

BEDMINSTER CREAMERY, C. 1905. Bedminster and Hilltown Townships were farming communities. Creameries were common so that farmers had only a short distance to travel. This creamery was located along Pennsylvania Route 113, east of Bedminsterville. The building is still standing. (Hockman collection.)

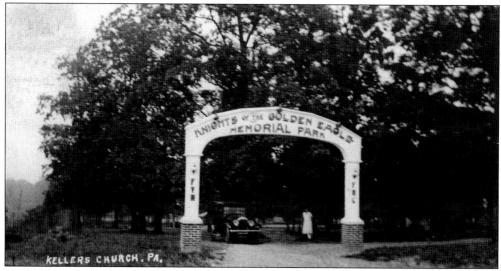

KELLERS CHURCH, PARK, C. 1928. Kellers Church is not a town, but a location with a church and a park where local farming families came together to worship, play, and socialize. This park was located in northern Bedminster Township. (Hockman collection.)

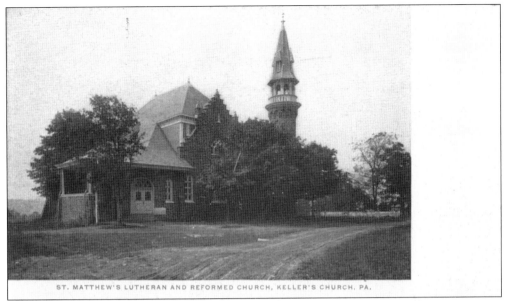

ST. MATTHEW'S LUTHERAN AND REFORMED CHURCH, KELLER'S CHURCH, PA.

KELLERS CHURCH, 1903. This postcard was made just five years after this church was built. At first it was a union church serving the congregations of St. Matthew's Lutheran and the Reformed Churches. It is believed that some of the Irish workers who dug the Perkasie Tunnel and died of cholera were buried near this location in unmarked graves.

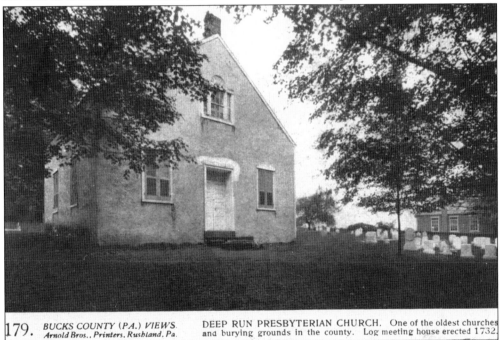

179. *BUCKS COUNTY (P.A.) VIEWS.* DEEP RUN PRESBYTERIAN CHURCH. One of the oldest churches
Arnold Bros., Printers, Rusbland, Pa. and burying grounds in the county. Log meeting house erected 1732.

DEEP RUN PRESBYTERIAN CHURCH. Scotch-Irish immigrants were among the earliest settlers of Upper Bucks County, arriving in the 1730s. This small stone church was built in the 1830s, replacing the original log meetinghouse. The Scotch-Irish were strong supporters of the American Revolution. There are many graves of Revolutionary War veterans in the cemetery. Most Scotch-Irish migrated to the South after the Revolutionary War.

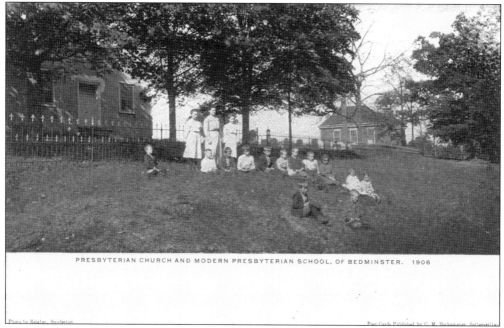

PRESBYTERIAN CHURCH AND MODERN PRESBYTERIAN SCHOOL, OF BEDMINSTER. 1906

Post Cards Published by C. M. Berkemeyer, Sellersville

DEEP RUN CHURCH AND SCHOOL, 1903. On the right is the one-room school that replaced an earlier one built by the Presbyterian congregation. It became a public school. The Deep Run Creek runs in front of both buildings.

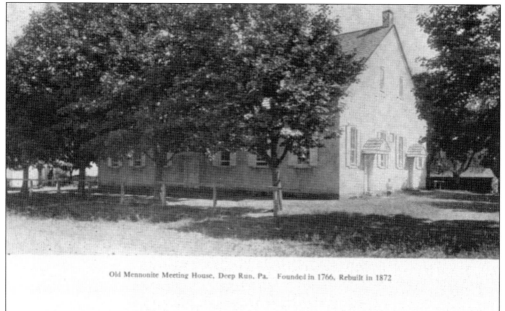

Old Mennonite Meeting House, Deep Run, Pa. Founded in 1766, Rebuilt in 1872

DEEP RUN MENNONITE MEETING HOUSE, 1903. German-speaking settlers came to Bedminster and Hilltown Townships before and after the American Revolution. One major Pennsylvania German group was the Mennonites, who lived pious, simple, hardworking lives. This was their earliest church in Bedminster. It has since been replaced. Nearby is one of the oldest one-room schoolhouses still standing.

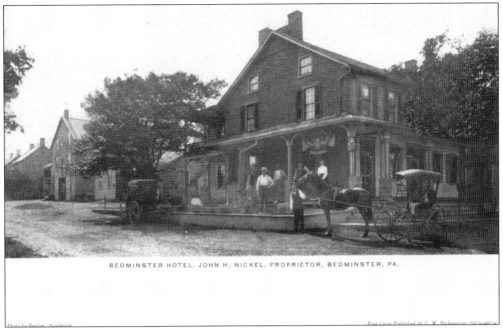

BEDMINSTER HOTEL, JOHN H. NICKEL, PROPRIETOR, BEDMINSTER, PA.

BEDMINSTER HOTEL, 1903. Modern-day Route 113 has been the primary road crossing Bedminster Township since Colonial times. The village of Bedminster is in the middle of the township. This postcard shows a hotel that is in a very rural part of Bucks County. Notice the livery stable behind the hotel.

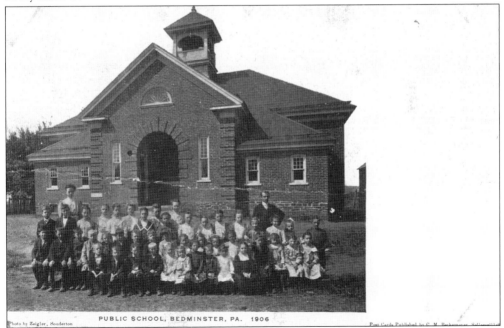

PUBLIC SCHOOL, BEDMINSTER, PA. 1906

BEDMINSTER PUBLIC SCHOOL, 1903. The traffic must have been slow because the students and teachers are on the road for this photograph! This two-room schoolhouse served the community in the central part of the township, housing grades 1–8. Today the building houses the Bedminster Township municipal government.

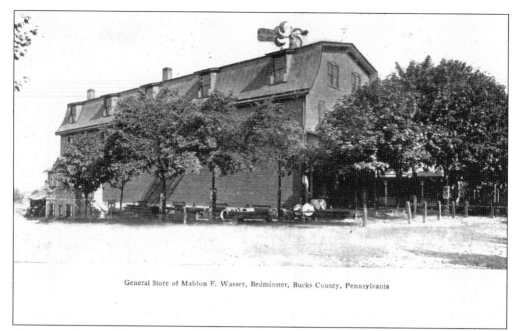

General Store of Mahlon F. Wasser, Bedminster, Bucks County, Pennsylvania

GENERAL STORE, BEDMINSTER, 1903. This large store was patronized by the rural residents of Bedminster Township. After churches, general stores were community centers for people to socialize. When the building burned in 1930, it was feared that the entire town was in danger because there was no nearby fire company. Fortunately, only this store was destroyed. The next year, a new store and post office were built in its place.

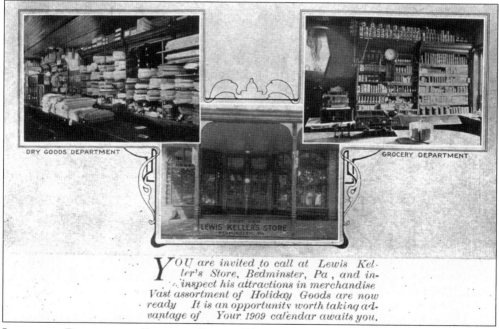

DRY GOODS DEPARTMENT

GROCERY DEPARTMENT

LEWIS KELLERS STORE
BEDMINSTER, PA.

YOU are invited to call at Lewis Kel-
ler's Store, Bedminster, Pa , and in-
spect his attractions in merchandise
Vast assortment of Holiday Goods are now
ready It is an opportunity worth taking ad-
vantage of Your 1909 calendar awaits you.

INTERIOR, BEDMINSTER GENERAL STORE. There is a new owner of the store, but this is the interior of the store shown above. (Hockman collection.)

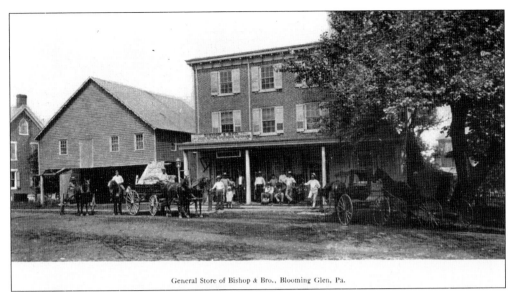

General Store of Bishop & Bro., Blooming Glen, Pa.

BLOOMING GLEN GENERAL STORE. Blooming Glen was the commercial center for much of Hilltown Township during the late 1800s and early 1900s. This store was run by the Bishop family. Blooming Glen is on Route 113, three miles southeast of Perkasie. Remarkably, one can still see this general store and its livery stable today with the only changes being the type of transportation and road surface. (Hockman collection.)

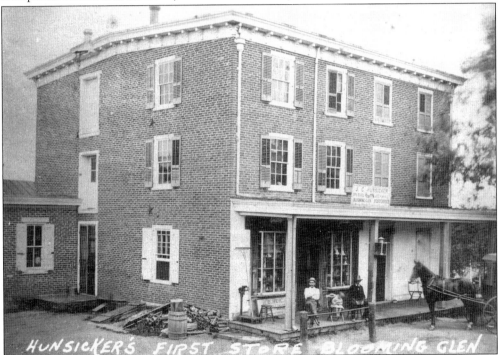

EARLIER VIEW. This is the same general store as shown above. The store sign states that the post office is also located here. This photograph postcard dates from the 1890s and has plenty of information about country living at that time. Explore this image for clues about how life was in rural Bucks County. (Hockman collection.)

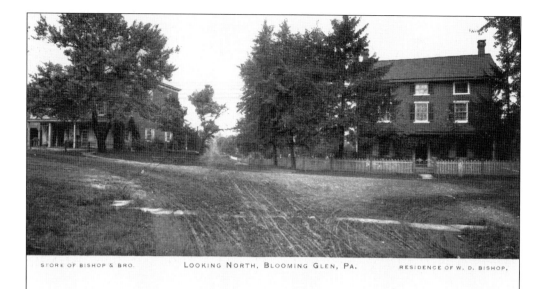

STORE OF BISHOP & BRO. LOOKING NORTH, BLOOMING GLEN, PA. RESIDENCE OF W. D. BISHOP.

BLOOMING GLEN INTERSECTION, 1903. These postcards show the major intersection of the Hilltown–Souderton Turnpike with Blooming Glen-Perkasie Turnpike. Several tollhouses lined the turnpikes to collect tolls whether one was driving a horse-drawn wagon or buggy, taking farm animals to market, or just walking. Tolls were used to maintain the compacted dirt roads. The store and home in both postcards were owned by W. D. Bishop, showing the affluence that could be obtained in rural Bucks County.

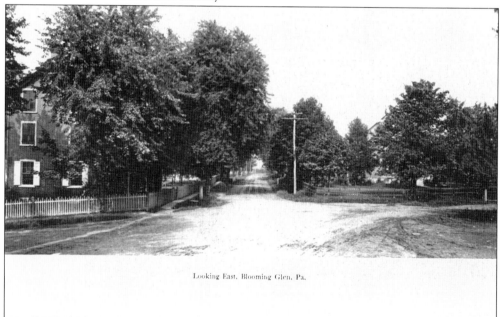

Looking East, Blooming Glen, Pa.

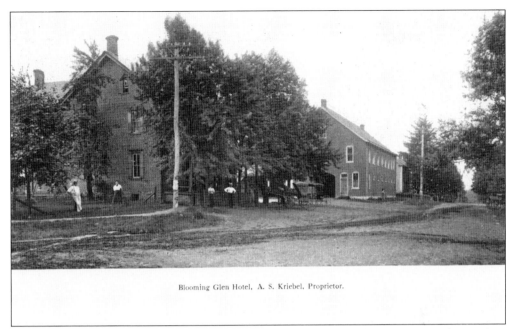

Blooming Glen Hotel, A. S. Kriebel, Proprietor.

BLOOMING GLEN HOTEL, 1903. This hotel is across the street from the store seen on the previous pages. It ran as a hotel and bar until the 1950s. Before cars, the building to the right was the hotel's livery stable with factory space on the second floor. Both buildings are still standing. The hotel is a private residence. The former livery stable/factory has been renovated for apartments and businesses. The photograph was taken facing west toward Silverdale.

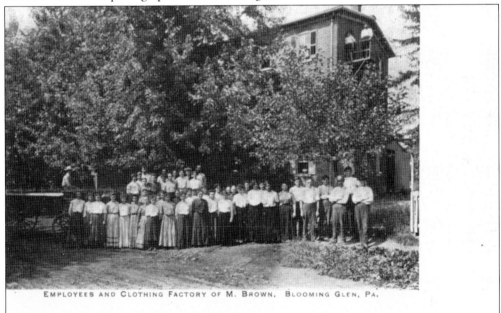

EMPLOYEES AND CLOTHING FACTORY OF M. BROWN, BLOOMING GLEN, PA.

CLOTHING FACTORY, 1903. Despite being in the countryside, Blooming Glen had several factories. The intersection of two roads seen on previous pages made it possible to transport workers, raw materials, and finished products. Like Perkasie, Blooming Glen's factories produced mainly clothing and cigars.

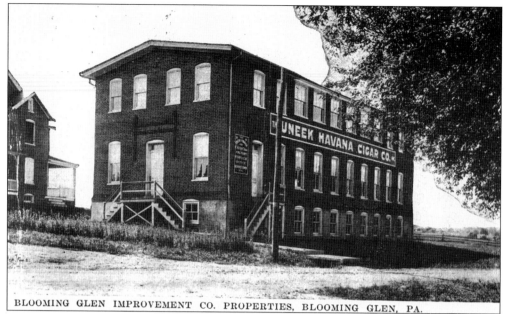

BLOOMING GLEN IMPROVEMENT CO. PROPERTIES, BLOOMING GLEN, PA.

CIGAR FACTORY, C. 1912. This is the same factory building as on page 111. However, it is now a cigar factory. During this time of rapid economic growth, it was not unusual for factory buildings and businesses to change owners and what they produced. In 10 years, the clothing factory became a cigar factory, owned by the Blooming Glen Improvement Company Properties. Apparently a real estate corporation was established in rural Hilltown Township. (Hockman collection.)

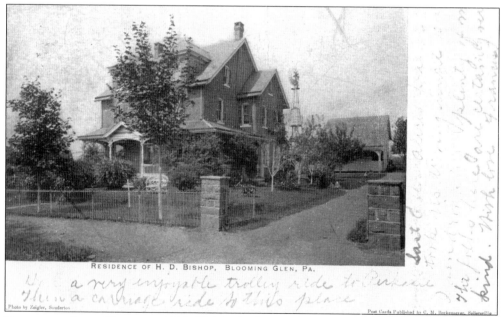

RESIDENCE OF H. D. BISHOP, BLOOMING GLEN, PA.

BLOOMING GLEN HOME, C. 1905. This is the home of the other brother who co-owned the Blooming Glen store. It represents the level of wealth that was possible in rural areas during America's Gilded Age, the 1880s to 1910. This home still stands on the northeast side of Route 113. (Hockman collection.)

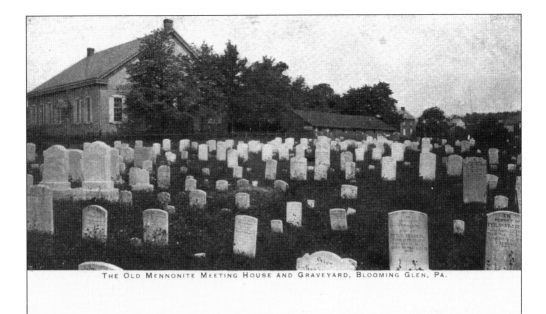

THE OLD MENNONITE MEETING HOUSE AND GRAVEYARD, BLOOMING GLEN, PA.

BLOOMING GLEN MENNONITE CHURCH. Mennonite immigrants came to Hilltown Township in the 1750s. Blooming Glen was one of the largest Mennonite congregations in America for much of its history. The rapid growth of this church can be shown in the history of its meetinghouses. From the first log meetinghouse built in 1753 to the present, there have been four different church buildings and many additions to them. The top postcard is from 1905 showing the small meetinghouse next to the Blooming Glen–Perkasie Turnpike. This part of the cemetery can be visited today with little change. Due to the increasing size of the congregation, being too close to the road, and the noise of motor vehicles, the early church was razed and replaced with the church seen in the lower postcard. This church was completed in 1939. Since then the church has been added on to many times.

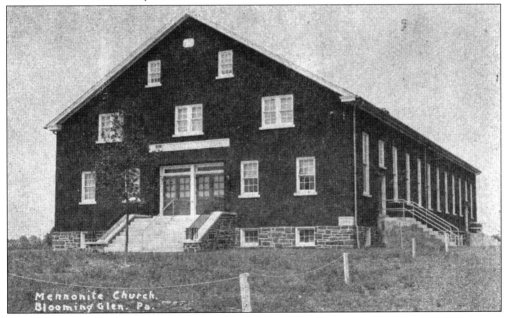

Mennonite Church.
Blooming Glen. Pa.

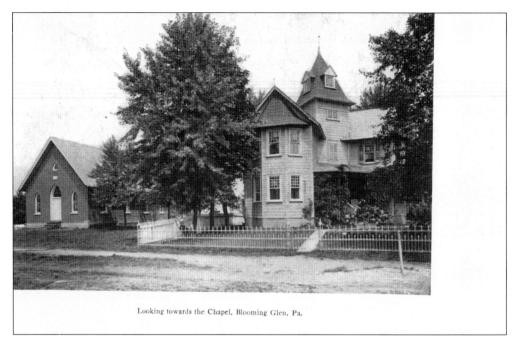

Looking towards the Chapel, Blooming Glen, Pa.

CHAPEL BECOMES HIGH SCHOOL. The small building was a chapel for a small congregation during the first years of the 20th century. However, when the congregation moved on, the local school board purchased it and made it the high school for Hilltown Township. At first students could only complete grade 8, later up to grade 11. If students wanted to complete all 12 grades, they had to commute to high schools in Doylestown, Sell–Perk, or Souderton. The school was part of the Deep Run School District for Hilltown and Bedminster Townships. In the early 1950s, it joined the Pennridge School District. When it was closed as a school in 1963, Hilltown Township used it as its municipal building for more than 20 years. (Below, Hockman collection.)

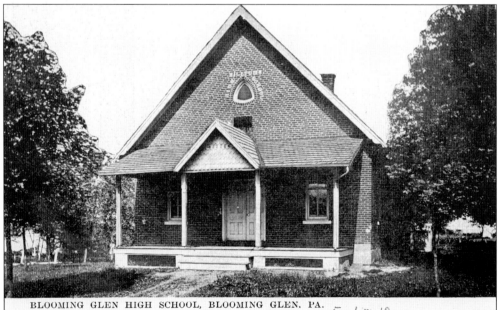

BLOOMING GLEN HIGH SCHOOL, BLOOMING GLEN, PA.

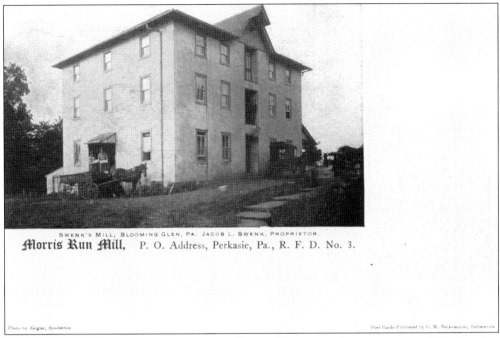

SWENK'S MILL, BLOOMING GLEN, PA. JACOB L. SWENK, PROPRIETOR.

Morris Run Mill, P. O. Address, Perkasie, Pa., R. F. D. No. 3.

Photo by Zeigler, Souderton Post Cards Published by C. M. Berkemeyer, Sellersville

MORRIS RUN MILL, 1905. Gristmills or flour mills were an important part of the farming community. Farmers brought their corn, wheat, barley, and other grains to be ground into flour. Animal feed was also produced by mills. This mill is still standing in a field near Minsi Trail not far from Route 113. Remains of the millrace (man-made stream to power a mill) can be seen along the north side of Route 113 and Minsi Trail. The lower postcard shows the milldam and the bridge that crossed Morris Run, a fast current stream. Water to power the mill ran from behind the dam through the millrace to the waterwheel. With a change of owners it became Schwenk's Mill, and a nearby road bears that name.

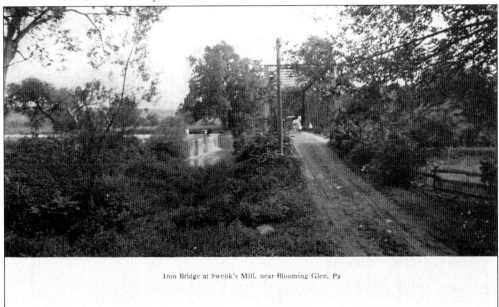

Iron Bridge at Swenk's Mill, near Blooming Glen, Pa

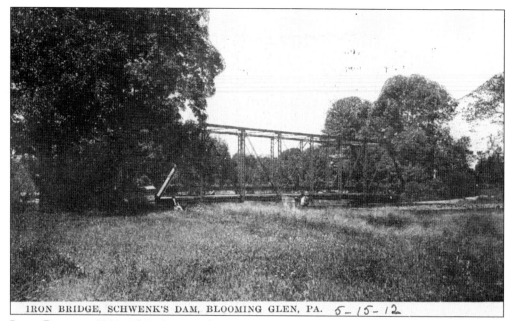

IRON BRIDGE, SCHWENK'S DAM, BLOOMING GLEN, PA. 5-15-12

IRON BRIDGE, 1912. This photograph was taken shortly before the iron bridge was replaced. When motor vehicles came to rural Hilltown they had problems making the sharp turn onto the iron bridge. Therefore Route 113 was straightened out and the bridge was replaced. Today this iron bridge stands aside of the highway, being preserved by the property owner and the Bucks County Conservancy. (Hockman collection.)

PRIMARY AND GRAMMAR SCHOOL, BLOOMING GLEN, P

BLOOMING GLEN'S OTHER SCHOOL, 1912. This was the primary and grammar school for Blooming Glen and the nearby farm families. It is unusual for a rural community because it is two stories high. When Deep Run Schools joined the Pennridge School District it was sold at auction. Blooming Glen Pork Company has built additions to this building for its business use. (Hockman collection.)

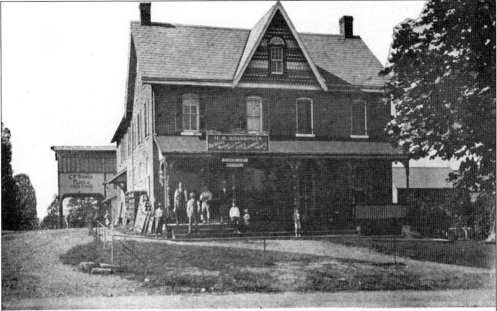

H. R. SHADDINGER'S GENERAL STORE, BLOOMING GLEN, PA.

SHADDINGER'S GENERAL STORE, 1905 AND C. 1935. Shaddinger's Store has been a Blooming Glen landmark since 1900. Today is houses the post office and apartments with few changes to its facade. But for most of its history it was a general store and post office, so nearly everyone in Blooming Glen made daily visits to it. Notice the difference in what is emphasized in each postcard, the 1905 image (above) shows the livery stable and feed store, while the *c.* 1935 image has cars and a gas pump in it. Means of transportation was always on the minds of people. (Hockman collection.)

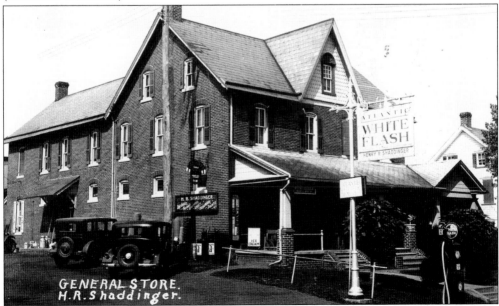

GENERAL STORE.
H.R. Shaddinger.

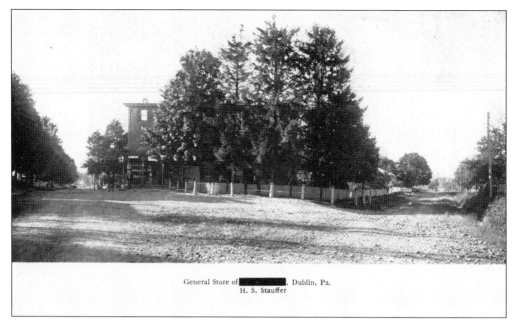

General Store of ▮▮▮▮▮▮▮, Dublin, Pa.
H. S. Stauffer

DUBLIN, STAUFFER'S STORE, C. 1905. This store is now a hardware store in Dublin where five roads intersect. What has greatly changed are the roads. The narrow dirt street on the left is now Route 313 with very heavy traffic. Route 313 was not a major highway until it was straightened out for motor vehicles around 1925. The road on the right is Elephant Road.

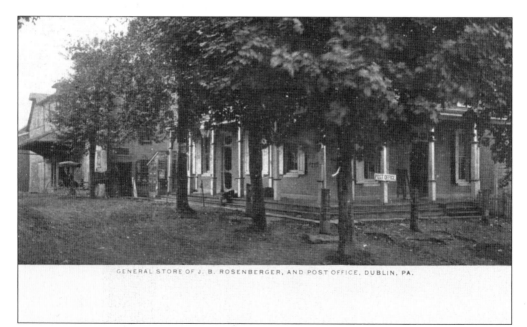

GENERAL STORE OF J. B. ROSENBERGER, AND POST OFFICE, DUBLIN, PA.

DUBLIN, THREE IN ONE, C. 1905. This building was a general store, post office, and livery stable. It is located across the street from Stauffer's Store, so there must have been enough people going to Dublin to purchase their needs and wants. The building still stands at Five Points, between Maple Avenue and Main Street (Route 313). (Hockman collection.)

118

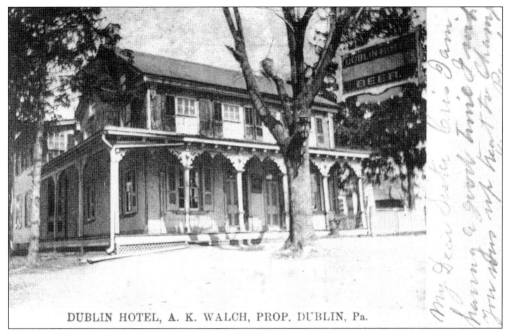

DUBLIN HOTEL, A. K. WALCH, PROP. DUBLIN, Pa.

DUBLIN HOTELS, C. 1906. The origin of Dublin's name is uncertain. Tradition has it as not being named after Ireland's capital. There were very few Irish in this area during the 1800s. However, it is believed that Dublin is a corruption of its early nickname of "Double Inn." These two postcards show early inns or hotels of Dublin. Over time, the use of the inn changed. Today the Dublin Inn (above) is a bar. The former inn (below) has various businesses today. (Hockman collection.)

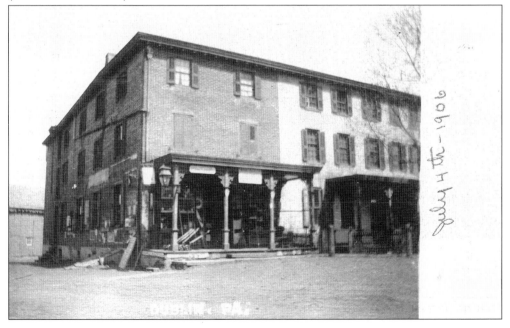

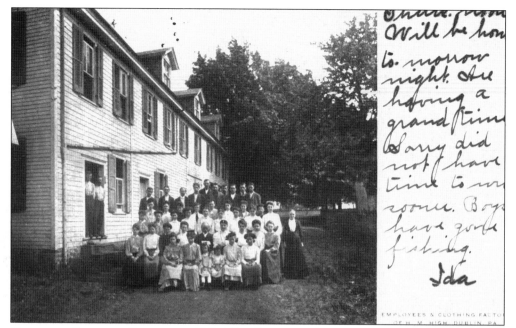

CLOTHING FACTORY, DUBLIN, C. 1910. Like Blooming Glen and Perkasie, having several roads attracted businesses and factories. Here are the employees of H. M. High's clothing factory. The location is uncertain, but it is believed to be on Maple Avenue. Notice the very young workers in the front row and the number of women versus men.

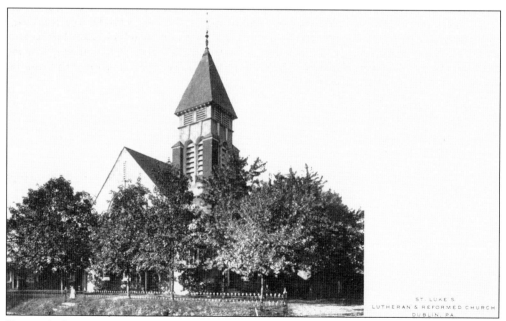

DUBLIN'S OLDEST CHURCH, C. 1905. Built in 1891, this church was a union of two congregations, St. Luke's Lutheran and Reformed Church. Today it is St. Luke's United Church of Christ. The Lutheran congregation built a new church just north of Dublin in the early 1960s, called St. Luke's Lutheran.

Dublin Creamery Association Building. Dublin. Pa.

DUBLIN CREAMERY, C. 1905. Farmers often joined together to form business associations or cooperatives in order to more efficiently process and market their dairy products such as milk, cream, cottage cheese, and so on. The Dublin Creamery Association building is believed to have survived but has been significantly modified in the past 100 years. Today it is an apartment building. The location is on North Main Street (Route 313). This view is facing away from the center of town. (Hockman collection.)

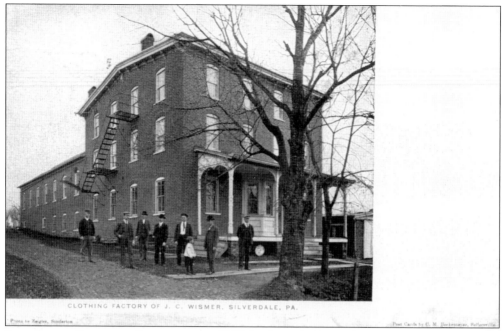

CLOTHING FACTORY OF J. C. WISMER, SILVERDALE, PA.

SILVERDALE CLOTHING FACTORIES, *C.* **1905.** In the early 1890s, the residents of a small village petitioned Bucks County Court to become their own self-ruling town, a borough. In 1896, the petition was granted. Silverdale was only two miles away from Perkasie with its train station and larger population of workers. Factories moved into Silverdale because many roads came into here, giving easy access to freight trains and the Philadelphia–Bethlehem Road. Clothing manufacturing was the primary industry of young Silverdale. This is the Wismer Clothing Manufacturing in both photographs. (Hockman collection.)

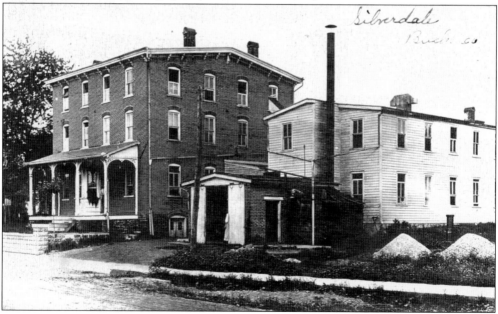

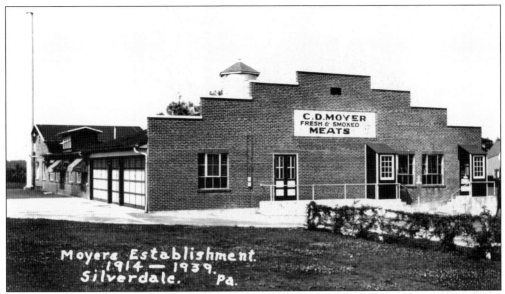

MOYER'S MEATS, SILVERDALE. Moyer's meat business was started in 1914 on Route 152 just north of Silverdale. Several meat-processing plants were established in the area because farmers raised high-quality beef cattle and other meat animals. Meats could also get to the huge Philadelphia and Allentown-Bethlehem markets quickly by freight trains, later by refrigerated trucks.

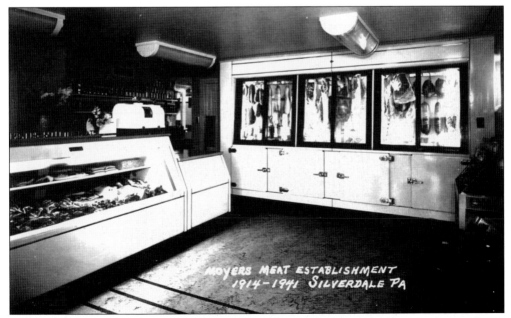

INTERIOR, MOYER'S MEATS, 1941. Moyer's Meats also had a retail store, at first with just different kinds of meats, as seen in this photographic postcard. In the 1960s, Moyer's opened a supermarket, but it was short-lived. The entire Moyer's Meats business was demolished in the 1990s to make room for a modern business complex. (Perkasie Historical Society.)

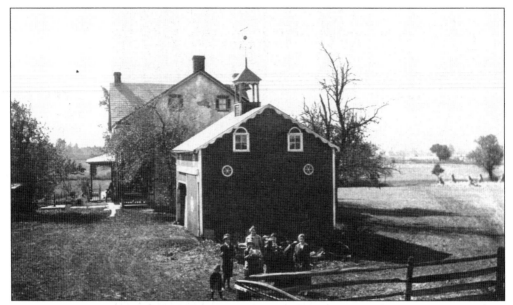

HILLTOWN TOWNSHIP FARM, C. 1915. Hilltown Township borders Perkasie to the south. Many of its farmers and other residents came to Perkasie for business, social, or recreational purposes. Here is a small farm in Hilltown. The barn is small, giving a clue that it is likely a truck farm, which meant the family grew vegetables and raised chickens, rabbits, and other animals for sale in Philadelphia. These farmer merchants were called hucksters, but in a nice way. This is the Oliver Nase homestead on Schwenk Mill Road. (Perkasie Historical Society.)

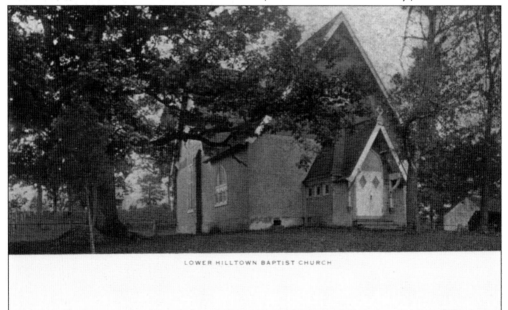

LOWER HILLTOWN BAPTIST CHURCH

EARLY HILLTOWN CHURCH, 1903. The earliest European settlers of Hilltown were from Wales, British Isles, coming in the 1730s. Thomas and Mathias were two of the most prominent early families, most were Baptists. They are buried in this church's cemetery. This church was razed for a new, larger Hilltown Baptist Church more than 40 years ago. Tradition has it that Native Americans who converted to Christianity were buried in this cemetery.

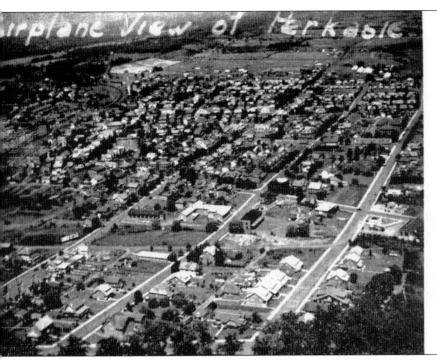

irplane View of Perkasie

Perkasie, Pa.
Midway between Phila
delphia and Allentown

Population of approxi
mately 4,000 persons

Eight Churches
Public Parks
Service Clubs
New Swimming Pool
Public Playground

AERIAL VIEW OF PERKASIE, C. 1940. Population statistics show that Perkasie was a boomtown. In 1880, one year after incorporation, Perkasie had 300 residents. In 1900, the population was 1,803 residents, it was 2,800 in 1910, 3,500 in 1930, and nearly 4,000 in 1940, when this photograph was taken from a plane. It should be noted that South Perkasie, the Third Ward, is missing from the photograph. Menlo Park is also not shown; it is beyond the lower right-hand corner.

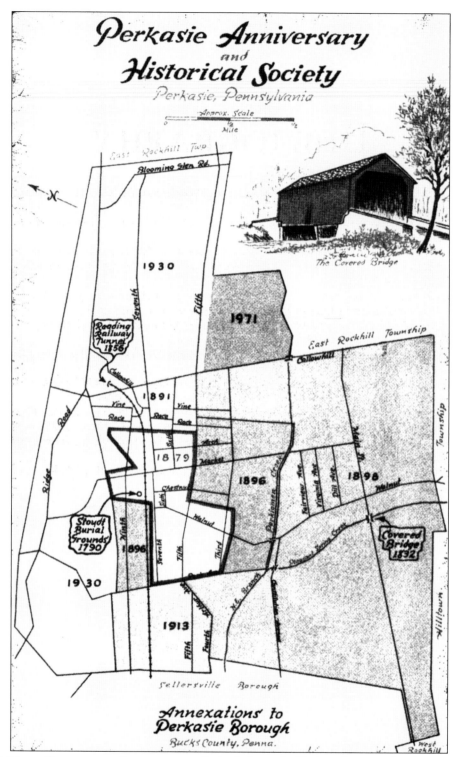

The Covered Bridge

PERKASIE, GROWTH BY ANNEXATION. Perkasie is nearly 10 times larger today than in 1879 because of annexing neighboring land six times, in 1891, 1896, 1898, 1913, 1930, and 1971.

BIBLIOGRAPHY

Cassel, Pauline. *History of Bedminster, Bucks County, Pennsylvania.* Bedminster, PA: Bedminster Bicentennial Committee, 1976.

Centennial Committee of Perkasie Historical Society. *The History of Perkasie, 1879–1979.* Perkasie, PA: News-Herald, 1979.

Grim, Webster. *Bucks County Directory, 1894.* Doylestown, PA: James D. Scott, 1894.

Fifth Annual Fair of the Bucks County Agricultural Fair, Menlo Park, Perkasie, PA. September 16–19, 1914.

50th Anniversary Edition: Official Program, Perkasie's Fiftieth Anniversary, June 15–22, 1929. Vol. 1, no. 4. American Legion Hartzell-Crouthamel Post, June 1929.

McKelvey, William Jr. *Lehigh Valley Transit Company's Liberty Bell Route.* Berkeley Heights, NJ: Canal Captain's Press, 1989.

McNealy, Terry A. *Bucks County: An Illustrated History.* Doylestown, PA: Bucks County Historical Society, 2001.

Moyer, James I. *The History of Perkasie: June 9, 1881 to August 16, 1945 Through the Eyes of the Central-News.* Buckingham, PA: Buckingham Impressions, 1999.

Perkasie Borough, Bucks County, Penna.: 50th Anniversary, Historical Souvenir Edition. Compiled by Perkasie 50th Anniversary Committee. Perkasie, PA: Central News, 1929.

75th Anniversary Perkasie, PA Historical Edition. Compiled by History Committee, Perkasie Historical Society. Perkasie, PA: News-Herald, 1954.

Ruth, Johnson Phil. *A North Penn Pictorial.* Souderton, PA: Indian Valley Printing, Ltd., 1988.

www.pennridge.org/grassroots/grassroots.html

www.pennridge.org/p/perkasie.html

ACROSS AMERICA, PEOPLE ARE DISCOVERING
SOMETHING WONDERFUL. *THEIR HERITAGE.*

Arcadia Publishing is the leading local history publisher in the United States. With more than 3,000 titles in print and hundreds of new titles released every year, Arcadia has extensive specialized experience chronicling the history of communities and celebrating America's hidden stories, bringing to life the people, places, and events from the past. To discover the history of other communities across the nation, please visit:

www.arcadiapublishing.com

Customized search tools allow you to find regional history books about the town where you grew up, the cities where your friends and family live, the town where your parents met, or even that retirement spot you've been dreaming about.